RENDEZ-VOUS WITH ART

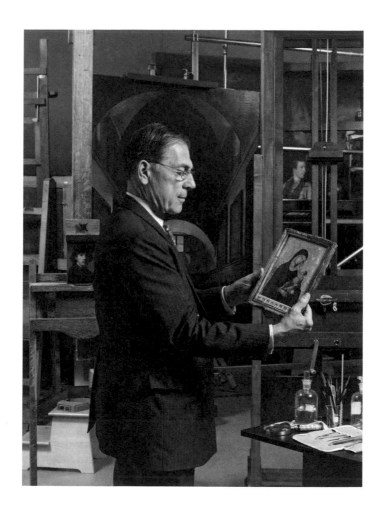

Philippe de Montebello holding the Duccio *Madonna and Child*,
c. 1290–1300, bought by the Metropolitan Museum of Art in 2004

RENDEZ-VOUS
WITH ART

Philippe de Montebello
Martin Gayford

75 ILLUSTRATIONS

First published in 2014 in hardcover
in the United States of America
by Thames & Hudson Inc.,
500 Fifth Avenue, New York,
New York 10110

thamesandhudsonusa.com

Library of Congress Catalog Card Number
2014932752

ISBN 978-0-500-23924-7

Printed and bound in China
by C&C Offset Printing Co. Ltd

Contents

Yellow Jasper Lips
at the Met

Philippe de Montebello pauses in front of a piece of shattered yellow stone. *'This'*, he exclaims, *'is one of the greatest works of art in the Metropolitan Museum of Art, indeed in the world, of any civilization!'* The object we are looking at is part of a face, the lower section. Of the upper portions – the brow, the nose, the eyes – nothing remains.

Those sheared off long ago, in one of the innumerable accidents that occurred during the approximately 3,500 years since the sculptor finished carving it. What is left is just the chin, fractions of cheek and neck, and the mouth. Essentially, the sculpture is a pair of lips as full and sensual as those of Mae West, which were once recycled by Salvador Dalí in the form of a surrealist sofa. In its way it is every bit as enigmatic as the *Mona Lisa*; there is no smile, only an expression of the mouth, as if the lips were about to part.

This splintered remnant portrays the face of an Egyptian woman who lived in a palace on the Middle Nile in the 14th century BC. She might have been Nefertiti, or she might not. We do not know, and it is extraordinarily unlikely that anyone will ever find out. The only way would be to discover the rest of the carving, broken and discarded probably thousands of years ago.

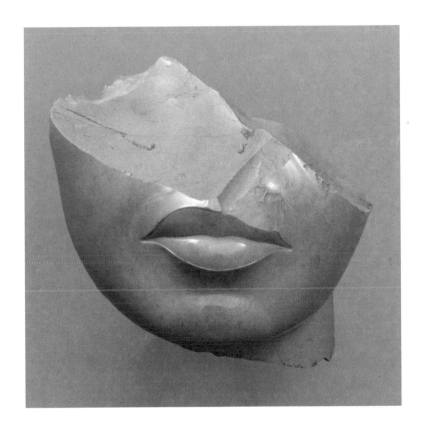

Fragment of a Queen's Face,
New Kingdom Period, *c.* 1353–1336 BC, Egypt

'If you told me you'd found the top of the head', Philippe continues, *'I'm not sure I would be thrilled because I am so focused, so absorbed and captivated by the perfection of what is there; that my pleasure – and it is intense pleasure – is marvelling at what my eye sees, not some abstraction that, in a more art historical mode, I might conjure up. It's like a book that you love, and you simply don't want to see the movie. You've already imagined the hero or the heroine in a certain way. In truth, with the yellow jasper lips, I have never really tried to imagine the missing parts.'*

—

The point about the mouth of the anonymous Egyptian queen (or, perhaps, princess), is that it is a fragment. That is its fascination. In a way, however, everything around us in the Met is a fragment: as well as the yellow jasper carving, there are bits of buildings, parts of sculptural ensembles, rooms from houses, and paintings that have been removed from the walls of villas and palaces.

What we see in the Met – or any other museum or collection – are elements detached from a greater whole. The Egyptian woman's lips are part of her face, but they have also been broken off from some context, quite what we do not know, that made sense during the reign of the Pharaoh Akhenaten. And that epoch, with its distinctive styles and beliefs, was only a passing moment in the period of the New Kingdom, which forms a sub-section of the long, long history of Egyptian art and civilization, and in turn takes its place in the wider chronicle of the ancient Near East and Mediterranean. So it goes on, like a set of Russian dolls, each fitting into something larger.

MG One day, while I was sitting for a portrait to Lucian Freud, I asked him what, for him, was the most difficult aspect of painting such a picture. His answer was a surprise: that he changed all the time. 'I just feel so different every day that it is a wonder that any of my pictures ever work out at all.' A few days later, it emerged that I – the subject – constantly altered too. Therefore, his attempt to make

an enduring image was also an effort to track two moving targets: artist and model.

What was true of Lucian in 2004 surely applies to some extent to all of art and life. If we stand in front of a work of art twice, at least one party – the viewer or the object – will be somewhat transformed on the second occasion. Works of art mutate through time, albeit slowly, as they are cleaned or 'conserved', or as their constituent materials age. Even if they remain visually identical, they may make a different impression according to the company they keep. Next to a Salvador Dalí, the Egyptian queen would not seem the same at all.

We, the viewers, however, are yet more fluctuating. Had I not been walking through the Met in Philippe's company on that bright autumn day, I would probably not have paused in front of the yellow jasper lips; certainly I would not have seen them as I did, because I looked at them in his company. The next time I saw them would be inflected, together with many other factors, by the memory of the first time. For his part, Philippe had seen this fragment hundreds of times before – which doubtless coloured his reaction, as did the fact that on this occasion he was looking at them with me, listening to my reaction to his response. Everything is like that.

Inevitably, we all inhabit a world of dissolving perspectives and ever-shifting views. The present is always moving, so from that vantage point the past constantly changes in appearance. That is on the grand, historical scale; but the same is true of our personal encounters with art, from day to day. You can stand in front of Velázquez's *Las Meninas* a thousand times, and every time it will be different because you will be altered: tired or full of energy, or dissimilar from your previous self in a multitude of ways.

Philippe and I had embarked on a joint project: to meet in various places as opportunities presented themselves in the course of our travels. Our idea was to make a book that was neither art history nor art criticism but an experiment in shared appreciation. It is, in other words, an attempt to get at not history or theory but the actual experience of looking at art: what it feels like on a particular occasion, which is of course the only way any of us can ever look at anything.

The result is affected by random factors – aching backs, closing hours, passing whims – as such experiences always are. It is also permeated by an emotion that is generally filtered out of writing on art, or reduced to a cliché: love.

The old French word 'amateur' has acquired many meanings. Originally, it signified 'one who loves something'. In modern English it implies 'non-professional'. Both Philippe and I spend our working lives engaged in art in one way or another, but in the original sense we are both amateurs of art: we love it. Igor Stravinsky once wrote that his first destination, on arriving in a new city, was the art gallery. Philippe and I both feel the same: a new collection, an unvisited church, mosque or temple is a thrilling prospect. To see such things is at least half the point of travel – and this is, among other things, an unusual variety of travel book.

MG Philippe, can you think of a single moment, a single experience that might have led you to a life in the arts?

PdM That's the toughest question, Martin, and the one most likely to yield an invention, or a half truth. But since an episode just happens to spring to mind, let's go with it. It was my first love, actually, a woman in a book.

She was Marchioness Uta in Naumburg Cathedral and I loved her as a woman. When I was maybe fifteen years old, my father brought home a book called *Les Voix du Silence* by André Malraux. I leafed through it, looking at its great, four-tone black-and-white illustrations. And suddenly there was Uta, with her wonderful high collar, and her puffed eyelids, as though after a night of lovemaking. She stands perhaps twenty feet up in the west choir of the building, so you could never see her so close in reality. But then I was seeing her in a book, held in my hand. I still think she's one of the most beautiful women in the world. I've since discovered, a bit to my dismay, that she can be found all over Internet, because it seems I'm not the only person who thinks she's supremely alluring.

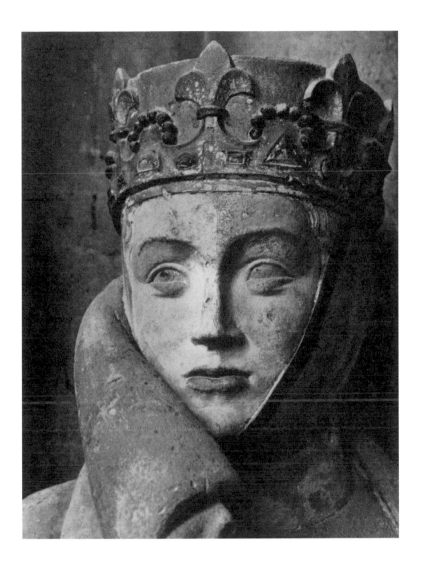

Detail of the statue of Uta,
Naumburg Cathedral of St Peter and St Paul,
as illustrated in *Les Voix du Silence* by André Malraux

What follows are transcriptions of our reactions to diverse works, collections and museums, recorded as they occurred in six countries over a period of two years. There has been no attempt at comprehensiveness. The contemporary artist Damien Hirst entitled one of his works, *I Want to Spend the Rest of My Life Everywhere, with Everyone, One to One, Always, Forever, Now*. Assiduous art lovers are a bit like that, with respect to images and objects. They want to experience the totality of the global visual creation, from all times, equally, and as far as possible keep it all in mind simultaneously.

PdM We chose the places we visited in part because they were where our busy schedules overlapped or could intersect, in part quite deliberately on the impulse of the moment when we were in a particular city. There were many locations that we would have loved to visit and probably should have, but did not. I wish Berlin, Vienna, St Petersburg, Istanbul or Cairo had been on our mutual itineraries. Or that in Paris, we'd had time for the Musée national du Moyen Age, Cluny.

MG You and I have spent a great deal of our lives looking at art; that is what we have in common. We belong, however, to different parts of the art-world wood. I am a critic, writer and – frequently – interviewer of artists.

Philippe, on the other hand, has been right at the centre as Director of the Metropolitan Museum of Art, New York, for thirty-one years, 1977–2008. And before that he was a senior member of the Met's curatorial staff; indeed, with the exception of a brief sojourn as Director of the Museum of Fine Arts, Houston, he devoted his entire career to this institution, one of the world's greatest collections of art.

As we walked on from the yellow jasper lips, Philippe reflected on his relationship to art and museums.

PdM Since the museum has been my world for close to half a century, it could be construed that what follows are museological musings. In truth, while I shall certainly comment on a number of museum

issues, the focus will be on art. After all, I entered the museum world because it was there that I could find works of art and be with them on a daily basis; enjoy their physicality, hold them, move them about, and above all share my passion with others, many others. It is the contents that attracted me, not the container.

This is a book with two authors, but numerous points of view. It is a collection of moments, many actually standing in front of works of art, others more detached, not so much responding as theorizing. Sometimes, the two of us agreed, at other times not. On occasion an idea emerged from the interchange between us, not precisely the invention of either.

PdM We've threaded our reactions, responses and conversations together to make a book about how we experience art, how we look at it, how we think about it, and – as with the rest of the Egyptian woman's face – how we try to put back what's missing from the thing we see in front of us. It's not simply a book about museums, although they play a big part in it because the museum, very often – with pleasure, exultation, boredom or irritation – is where we encounter art.

An Afternoon
in Florence

In June 2012 we met in a city so crammed with art that its very name is a byword for pictures and sculpture. To visit Florence without visiting churches and museums would be perverse. It is also a place where you can experience the first morphing into the second: site of worship into temple of art appreciation. Our very first port of call was not a fragment but a whole: a cycle of great pictures that was still on the walls on which it was painted over half a millennium ago.

Philippe was staying in Florence for a few days while he was speaking at a conference, and I flew over to join him. My hotel was in Oltrarno – the district on the south bank of the Arno. As soon as I arrived, we met, ate lunch, and went straight through the hot, almost deserted, streets to the Brancacci Chapel in the church of Santa Maria del Carmine. We bought our tickets and found – astonishingly – that we had the place to ourselves.

PdM It is, like so much of what we see, a visual palimpsest. That is, a series of images and interventions placed side by side, or superimposed, through time.

Masaccio and Filippino Lippi, *Raising of the Son of Theophilus
and St Peter Enthroned* (detail),
1425–27 and *c.* 1481–85, Brancacci Chapel

The chapel was built by Pietro Brancacci around 1386; almost forty years later the fresco decoration was probably commissioned by his nephew from Masolino, who worked with his younger associate, Masaccio. The frescoes were left unfinished until the end of the 15th century, when the cycle was completed and parts altered by a third great painter, Filippino Lippi. It has been a shrine of art almost as long as it has been a place of worship. The young Michelangelo came here to copy Masaccio's frescoes and thus learn how to draw.

Subsequently, the church experienced both disasters and transformations, including a fire and an architectural remodelling in the late 18th century. The frescoes were cleaned and restored in the late 20th century. But still we felt, when we stepped into the chapel itself, that we were entering a time capsule: a room of 15th-century pictures.

PdM The key is that we are *stepping* into that era. You realize here what museums simply cannot do, which is to put you within the frame, almost within the world and the time of the artist. Of course, one can never re-enter the past, that moment has gone. But this is as close as one can ever get. In this chapel, everything leads one into it – above all the corporeal reality of Masaccio's figures. Their sense of weight and presence must have caused amazement at the time. Already they show such key elements of Renaissance art as gravity, seriousness and moral authority. They display an assertiveness and a calm severity that reflects the city's growing self-confidence.

———

From the Brancacci Chapel, we proceeded back across the Arno to the eastern quarter of the city, to the basilica of Santa Croce. It is a huge church, begun at the very end of the 13th century for the Franciscan order, but only completed in the mid-15th, with some alterations carried on in the late 16th by Giorgio Vasari, painter, architect and, through his *Lives of the Artists*, the grandfather of modern art history. The façade was added in the 19th century.

Santa Croce remains a church, but quite early on it began to change into something else: a pantheon, the place of burial of famous Florentines, and by the 19th century a Valhalla of celebrated Italians. The tomb of Michelangelo is to be found here, also those of Galileo, Machiavelli and Rossini. Because of the artists who carried out decorations in the basilica, it soon took on another character.

The building became an assembly of great works of art, in other words, a sacred space transformed for art lovers into a museum. It seemed quite appropriate, therefore, that we had to queue at a ticket office before going in, as if we were at the Louvre or the Met. Already in the 1490s, the young Michelangelo also studied here, copying the frescoes by Giotto in the Peruzzi and Bardi Chapels. In the basilica are to be found works in painting, sculpture and architecture that, taken together, are a sort of early canon of Florentine art: works by Giotto, Brunelleschi, Donatello and many others. But there is one difference between Santa Croce and any actual museum: all the works here were made to go in this place.

PdM We are in front of Desiderio da Settignano's tomb of Carlo Marsuppini, the chancellor of Florence and early humanist. Its wonderfully light sarcophagus, decorated with acanthus leaves, seems almost to be taking flight, lifted by a winged scallop shell that has been interpreted as symbolizing the journey from life into death and ultimately into the spiritual realm. On either side stand two delightful and slightly impish putti with shields, keeping guard.

The sarcophagus itself is a great work of sculpture. How often in this museum age are you confronted with the 'architecture' of a sculptural ensemble in this way – the narrative as one unblemished whole, with all its parts, painted and sculpted?

Once again it reminds us how, in museums, we admire what are often fragments from larger ensembles. If one of these putti were pinioned on a pedestal in the Met or the Louvre we would still admire it; just the label would alert us to its original role as one small component of a much larger composition. But only in seeing the whole do you understand the relationship of the parts: how the stances of the

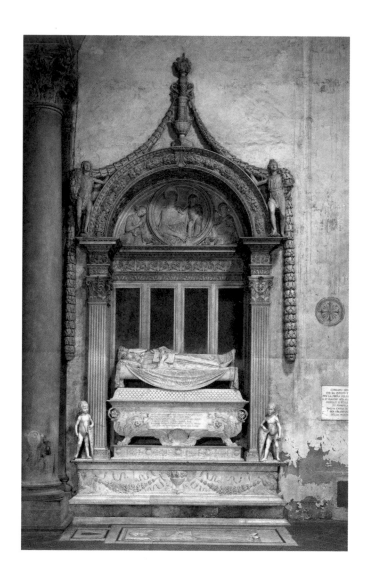

Desiderio da Settignano,
Tomb of Carlo Marsuppini, *c.* 1453,
Basilica of Santa Croce

putti relate to each other, their glance cognisant of the *gisant* – the effigy of Marsuppini. In its proper place, it is all so much more rich and, indeed, authentic.

MG It would lose something even if you extracted all the stones from the wall and took them to a museum.

PdM Exactly. Because the tomb was conceived to be set into the architecture of the church, of which it then became an integral part. Space, scale, acoustics even, and of course light, are all vital elements that would be lost if the ensemble was transferred to another place. That's the wonder of being here, in the strict sense. I say this because the church itself is now a museum, or functions as one, but a museum for which the works on view were originally intended and conceived.

Though not a part of a single decorative programme, the interior of Santa Croce is filled with accretions from many different periods and styles – layered history in full view. Sometimes what we see has been revealed by restorers, such as the Giotto frescoes that had been whitewashed over.

There are two chapels containing frescoes by Giotto, dating to c. 1320–25, but they are very dissimilar in condition. Both were discovered under whitewash in the 19th century, but they have been dealt with very differently by time.

The frescoes in the Bardi Chapel were painted in *buon fresco,* which bonds chemically with the plaster and, if the conditions are right, lasts very well. The frescoes by Giotto in this chapel have indeed lasted extremely well, except for those areas where tombs and monuments were inserted into the walls. Now what we see are areas of masterly painting by Giotto, interspersed and interrupted by the shapes of baroque arches and funerary structures, since removed.

The Peruzzi Chapel next door had a quite different fate due to the technique Giotto employed. He painted this cycle not in *buon fresco* but *a secco* – that is, he painted over the dry plaster so the paint did not bond, and it has

become rubbed and blurred over time. Recent analysis suggests that the original effect was as rich as panel painting.

PdM Here, we are very conscious of what we are missing. Originally, the colours would have been brighter, making the narrative much clearer and more powerful. Now, the effect is a bit like looking at a faded tapestry. If you look at the back of a tapestry, the difference in the vividness of colour between the front that has been exposed to light and the back is dramatic. The number of tapestries that are now totally washed out and thereby ruined is heartbreaking. If you could, you'd hang them wrong side out. When you compare the murals in the Peruzzi to those in the Bardi Chapel next door, you see how, through fading, time has diminished the impact of the fresco.

We moved on to the Baroncelli Chapel in the south end of the transept. It has a complete, and almost entirely well-preserved, series of frescoes of the *Life of the Virgin* by Giotto's pupil, Taddeo Gaddi, dating from *c.* 1328–38. Gaddi also designed the stained glass for the windows.

PdM Quite apart from their innovative treatment of space, light and narration, what is wonderful in the frescoes here is the decorative, colourful ensemble, the sense of a whole Bible illustrated around the walls. It gives us an idea of what Giotto's Peruzzi Chapel might have been like, with the *trompe-l'œil* and the columns and niches so much more striking in their original and intended colour scheme, harmoniously unifying the whole.

This chapel, dating from the early 14th century, has survived in an unusually intact state. Except, that is, for the frame of the altarpiece. The various panels of the altarpiece itself depict the *Coronation of the Virgin* and the *Glory of Angels and Saints*. The whole work is signed by Giotto himself, 'Opus Magistri Jocti' (A Work of Master Giotto), but many scholars have detected the hands of various others, including Taddeo Gaddi.

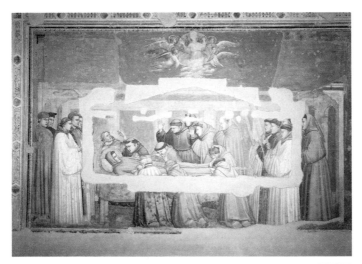

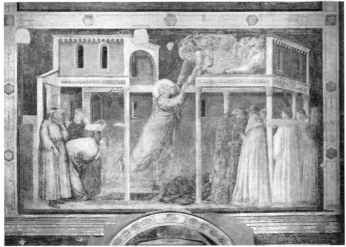

TOP Giotto di Bondone,
Funeral of St Francis, 1320s, Bardi Chapel
ABOVE Giotto di Bondone,
Ascension of St John the Evangelist, 1320s, Peruzzi Chapel

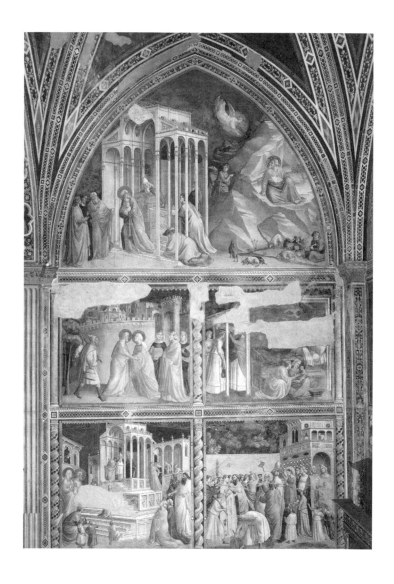

Taddeo Gaddi, *The Life of the Virgin*,
c. 1328–38, Baroncelli Chapel

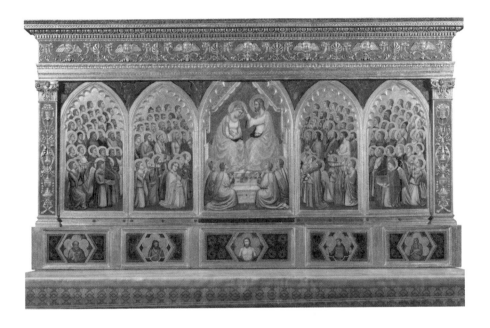

Giotto di Bondone, Altarpiece,
c. 1334, Baroncelli Chapel

PdM This polyptych by Giotto and his workshop, which is in excellent condition, is fascinating. Essentially, here Giotto can be considered a Gothic artist, notwithstanding his position at the beginning of the great humanist tradition of art. Then one notices that the altarpiece has been transformed into a Quattrocento picture; in the late 15th century it was entirely reframed *all'antica* by Ghirlandaio – but look at what else he has done.

The Christ and the four panels of saints in the predella below are not aligned with the centres of the panels above anymore. And when the Gothic frame was removed, all the tops of the arches were cut off so the panels would fit into the new rectangular frame.

MG These complex frames are almost works of architecture. Such a frame is a small structure that the painting inhabits in the way that frescoes inhabit the walls and ceiling of a chapel. It wasn't until the 16th century that people thought about matching the style of an image and its setting.

PdM Anachronism didn't seem to matter much in the Quattrocento. If you wanted to modernize an earlier polyptych, you got rid of the Gothic top, the pinnacles, the little pilasters, and it didn't matter that the predella panels were no longer centred.

Today, there is no question of changing the Santa Croce altarpiece back into a late Gothic one. This is not only because we don't have the missing parts, but also because the Ghirlandaio reframing represents a legitimate moment in time and in practice in the Renaissance, and it has been an integral part of the church for centuries.

What saddens me about the chapel in its present state is that the polyptych was painted by Giotto and associates specifically for this spot on the altar, which is surmounted by a large Gothic window. So if the frame had not been altered, we would step today into a perfectly preserved Florentine chapel of the early Trecento. Such an antiquarian bit of nostalgia doesn't square, of course, with Renaissance thinking or practice.

What art lovers nowadays often yearn for is a place that has somehow defied the destruction of time. Of course, it is an illusion. As Philippe said in the Brancacci Chapel, *'one can never re-enter the past, that moment has gone'.*

PdM There seems to be a universal human response to works of great age, one that goes beyond the constituent materials of the work itself to their immaterial value. Works of great age fascinate us, they bring us closer to lost civilizations, they are a tangible vestige of history. Age has conferred on such works a level of interest for us that was brilliantly analysed by Aloïs Riegl, the leader of the Vienna school of formalist art history around 1900. He discussed the modern cult of monuments and distinguished between 'historical value' and 'age value' (*Denkmalswert* and *Alterswert*); in the latter case, he argued that we value an old object for the sake of its age, for the alterations that nature and time have inflicted on it, however humble it might be; for the acute awareness of the distance that separates us in time and space from the object; and also for how close, even empathetic, we feel to the people who made it, so very long ago.

MG Yet there is another pleasure to be had precisely from the changes brought about by the passing years. There is the romantic pleasure of ruins, the change and what the English painter John Piper called 'pleasing decay' brought about by both man and nature. Decay, however, is also a process of destruction.

A Flood and a Chimera

It is not just the fragments in museum collections, but whole cities that are so beloved that we strive to keep them going, wishing them to remain as far as possible unchanged, even perhaps – impossible as it is – to try to make them more the way they once were. David Hockney has observed that things survive, broadly, for two reasons: either because they are made of some substance so hard it resists the effects of time, or because somebody loves them. That 'somebody' is often a corporate entity, such as a museum or organization: for example, the *Soprintendenza* of cultural property in Tuscany.

We were reminded of that fact on our Florentine visit when we wandered into the museum attached to the Franciscan basilica, the Museo dell'Opera di Santa Croce. This is in the old refectory of the friary and is filled with notable masterpieces of painting and sculpture. The building, and the great church itself, are in one of the lowest-lying parts of the city, close by the Arno. When the river catastrophically broke its banks in November 1966, both Santa Croce and the museum were filled with a churning mass of water, oil and mud. It did a great deal of damage, and almost totally destroyed some works.

PdM Among the victims of the 1966 disaster, one work stands out and that is the great Cimabue Crucifix.

This imposing, even massive, work, is a precious relic from the very dawn of the Renaissance, the moment when humanity and realism began to seep into the formulas that Italian artists had inherited from Byzantium. The swirling flood stripped the paint from much of the surface, particularly from the face and body of Christ. Years of careful restoration followed, but done in such a way as to leave the areas of damage clear and obvious. The effect, Philippe and I agreed, is so visually disruptive as to make it almost impossible to experience the Crucifix as a work of art.

PdM Although many options were available to conservators, such as judicious in-painting to reduce optically the traces of damage, which photographs of the work before the flood would have permitted, the Crucifix was left with its open wounds. It was singled out by the authorities to be a sacrificial and poignant memorial to the disaster, a bit like how, after the Second World War, the bombed-out Kaiser Wilhelm church in Berlin was left in its ruined state.

There are, unnoticed perhaps by most visitors, constant efforts to preserve the objects we see in museums — and elsewhere. This is, in Hockney's summary, the equivalent of the collective love we feel for certain fragments that have been preserved from past ages. Love, however, can be expressed in many ways, tough and tender. 'Conservation' and 'restoration' come, too, in a multiplicity of gradations, from gentle to intrusive, from cautious cleaning to radical, even drastic, restoration. Although many of the techniques involved are scientific, the final decision on the degree of intervention is often a matter of taste.

In the Museo dell'Opera del Duomo, which we visited after lunch, Philippe suddenly paused in front of Donatello's extraordinary life-size carving of the Magdalene. It acted as the madeleine soaked in tea famously did on Marcel Proust, as the sight of the sculpture unlocked the doors of memory and took him — and us — back almost fifty years.

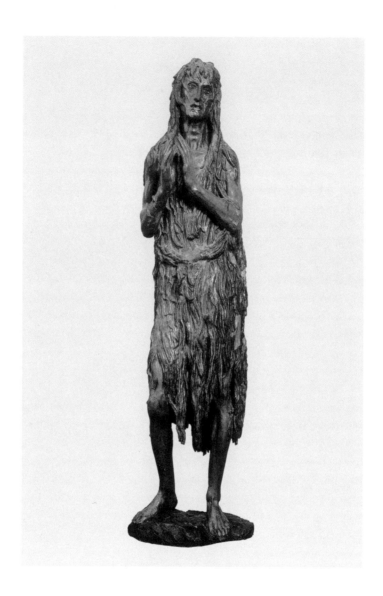

Donatello, *St Mary Magdalene*, c. 1457

PdM Donatello's *St Mary Magdalene* was not here, but inside the Baptistery when I first saw it, and it was half covered in mud. I was in Florence on a travel grant from the Met in the fall of 1966. It was late September when I arrived, and among the introductions I had was one to the aesthete and connoisseur Sir Harold Acton whose splendid villa, La Pietra, now belongs to New York University. He invited me to have lunch there on 5 November.

However, my little story starts in the early hours of the day before, the fourth, when after days of torrential rain, the Arno began to swell and threatened to burst its banks. That morning, I was actually crossing the Ponte Vecchio on the way back to my pensione in the Via dei Calzaiuoli when the waters did burst the river's banks. So I ran to the pensione, barely keeping ahead of the rushing waters; in fact, I may already have had wet feet as it was pouring rain, of course. At the pensione, we all moved upstairs and from my balcony I had a view towards the Piazza del Duomo, specifically the area between the Baptistery and the Duomo.

I could see the rushing water carrying cars and furniture down the street at great speed and, to my horror, slamming against the doors of the Baptistery, the so-called Gates of Paradise, that glorious testament to Renaissance innovation and genius. All of us stayed on the upper floors until the next morning when the water began to recede. The first thing I did was rush to the piazza, where there was total chaos, with people milling about in shock. I was wading through mud halfway up my calves, but managed to make my way to the Baptistery.

The east doors had been sprung open; the Ghiberti panels were partly detached and one or two were actually lying flat on the ground in the mud. There were no officials there, no police, but a few museum people in a daze to whom I showed my Met ID. The first thing I saw when I walked in was Donatello's *Magdalene*. She was still standing immediately on the left, I think, as you came into the Baptistery. She was black with mud up to about the level of her hands. There were a couple of other sculptures, also covered with mud. They removed her

very quickly; by the next day or two, I think, she had gone. After all, she must have been high on the list of works to be rescued. So you see, she and I have encountered each other before.

That was the day of my lunch with Sir Harold, and my first thought was, What am I going to do? Because of course there was no telephone, there were no vehicles, there was no means of communication, no way for me to call and cancel. So I decided I'd walk the three or four kilometres up to La Pietra.

I rang the bell, probably late and looking a sight; the footman opened the door and I said, 'I'm Philippe de Montebello'. He looked at me, incredulous, and asked, 'Aren't you coming to have lunch with Sir Harold?' I said 'Yes'. He responded, 'Looking like this?' Of course, they had no idea of what had happened down below. I told him that the Arno had flooded and that there was a disaster in Florence. He said, 'Oh, oh', called Sir Harold, who came and said, 'Young man, I was about to say one dresses up to come and see me.' I explained in a few words that there'd been a terrible flood and the Ghibertis were lying in the mud.

Naturally, we never had the lunch. He called his chauffeur, then we rushed and got into his car and drove as close to the city centre as we could. Sir Harold put on his hunting boots and we walked down to the Piazza del Duomo and entered the Baptistery. When Sir Harold saw the *Magdalene*, the Donatello, he just stood there and wept.

Over the next few days, I helped curators and conservators move things around, but there came a time when there were so many volunteers that they got in the way, and I left when my travel grant expired. Eventually, most of the frescoes that had been affected by the flood were saved, carefully peeled from the walls through the *strappo da muro* technique (pulling from the wall) and then in-painted using the *tratteggio* technique of hatchings, mostly for tonal harmony, rather than attempting precise but inevitably inexact transcriptions of details. There was one beneficial result of the tragedy: the discovery under a number of frescoes of elaborate preparatory drawings, called *sinopie* from the red earth pigment (*sinopia*) used to make them.

After leaving the Museo dell'Opera del Duomo, we walked north through increasingly uncrowded streets to one of the least frequented institutions in Florence: the Archaeological Museum. For every hundred visitors who cram themselves into the Uffizi, perhaps one, at most, comes here. It is an order of priorities that would have baffled Lorenzo the Magnificent, since in this place you can see one of his most prized possessions, an ancient bronze head of a horse. To Lorenzo, this would have seemed much more rare and precious than the efforts of contemporary artists who worked on his instructions – such as Botticelli, whose paintings are the Uffizi's greatest draw.

Philippe obviously has sympathy for Il Magnifico's point of view, since he had been determined since breakfast time that we should visit the Archaeological Museum. When we arrived, we discovered that we were virtually alone. Although there were many fascinating and beautiful things to see, we found ourselves standing repeatedly in front of one object: a bronze sculpture of a mythical beast – part lion, part goat, part snake – known as the Chimera.

PdM How many times have we returned to this gallery, how often have we been irrepressibly drawn back to it? A characteristic of great works of art is that they persistently catch our attention and beckon us. It is like a piece of music that we want to listen to ad infinitum or a book that we love re-reading – because one never exhausts what a great work has to give, whether it's in the detail or the whole. For example, we've been back to see this three times already, and I have waxed dithyrambic about the mane, its crisp tongue-like projections, erect and windswept; and the whole defensive–aggressive posture: that extraordinary melding of life and artifice.

However, it is only now, this time, that I've noticed the veins on the belly, yet another well-observed and transcribed detail, but these aspects do not explain why we keep returning to this room. It's because of the ferocity of that animal, its spirit, all the fruit of the creative imagination of the artist. This wasn't made by a mere craftsman; here we have the work of a real artist who has felt and thought deeply. He knew exactly what he wanted to convey and succeeded

brilliantly in doing so. I find that this can be said of just about every good work of art, and the reverse is true too. If between intent (even if only perceived intent) and realization there is a gap, then the work falls short.

Who that artist was, no one has any idea, nor of who commissioned the sculpture – or why. The only firm point is that it was made by, or at least for, an Etruscan, and dedicated to the Etruscan god Tinia, whose name is inscribed on the right foreleg. It has been suggested the sculpture might once have been part of a group with the equally mythical Greek hero Bellerophon, who slew the monstrous Chimera in a sort of precursor of the story of St George. (The Chimera, which breathed fire, sounds like a variety of dragon.)

If so, the statue of Bellerophon disappeared long ago. The Chimera was accidentally rediscovered in Arezzo by some workmen in November 1553 with some other Etruscan bronzes. The hoard was soon acquired by Cosimo I de' Medici, Grand Duke of Tuscany, who kept it in his collection at the Palazzo Vecchio in Florence. Benvenuto Cellini described in his autobiography how he and the Duke spent several evenings cleaning the smaller sculptures – Cellini wielding a miniature hammer and Cosimo holding tiny jeweller's chisels to remove the earth that stuck to them. Before it was found, the Chimera had lost its serpent-headed tail, which was not replaced until the 18th century. And that, effectively, is all we know – except that it is a unique masterpiece.

PdM Even if there was an iconographic tradition for such a chimera at the time, I venture to say that a great many of such sculptures would have looked pedestrian in comparison to this one.

The piece is dated around 400 BC – that is, around the traditional date of the foundation of Rome. That makes it, in terms of Italian antiquity, extraordinarily old. Yet it seems fresh, just as new as the Donatello sculptures in the Bargello that are 2,000 years younger. That is one of the qualities of that famously enduring material, bronze: it negates the normal effects of time, so

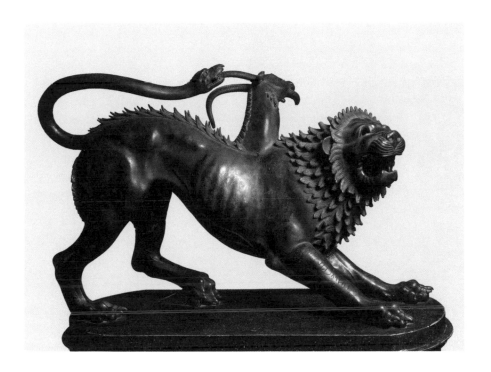

Chimera of Arezzo, 400–350 BC

that works made centuries or even millennia apart seem almost contemporary. Bronze, unless someone decides to melt it down, lasts amazingly well. In Hockney's formulation, it is the substance so hard it can survive even if unloved. That is the point of the Roman poet Horace's boast that his verses were a monument more lasting than bronze.

It was also the premise of a remarkable exhibition Philippe and I saw later that year at the Royal Academy of Arts, London. This gathered objects from many different times and places, having in common only the material: bronze. It was startling how certain pieces, such as the Chimera and a portrait figure from Herculaneum, which had been buried in the ground for millennia, looked almost new.

However, that is not the only reason the Chimera is so powerful. It has an ability not just to defy time, but also to communicate *through* time, even to people who do not and cannot know much about the beliefs of the people who made it or the message it was supposed originally to have. Somehow, inexplicably, a great work of art transcends its own age.

CHAPTER 3

Immersed in the Bargello

After dinner in the courtyard of the Palazzo Pitti (of which more later), we agreed to meet the next morning at the Bargello. This represents a later stage in the process of museumification. It began in the Middle Ages as a structure with an extremely practical purpose: a stronghold, a prison, a place of death and pain. In the mid-19th century, it was transformed into something entirely different: the Museo nazionale del Bargello, a repository of Renaissance and Gothic sculpture assembled from churches and public spaces around the city.

The Bargello was thus the product of the civic and governmental impulse to set up institutions in which the public could appreciate art. It was also, simultaneously, a symptom of the Romantic age. The works were brought together into a building redolent of history, a stone fortress full of atmosphere. But if you were commissioning a museum of Florentine sculpture and decorative art in the 21st century, you wouldn't come up with anything like this.

PdM Oddly, my first impression on walking into the courtyard is that the sculpted fragments displayed up and down the walls look like barnacles on the hull of a ship. The objects were brought from all

over Florence, then stuck on walls and on top of things; none of them is where it was originally meant to be. It has an improvisational character, which I really like. As I do the wonderful play of sunlight and shadows, the almost palpable sense of the history of the building; as one climbs the stairs, looking down at the stone courtyard, an image of rivulets of blood comes to mind … executions were held there: this, after all, was the Florentine Bastille, or Place de Grève.

It was built in 1255 as a residence for the Capitano del Popolo, or Captain of the People – an administrator representing the non-noble part of the population – after that it was the residence of the Podestà or chief magistrate, and in the 16th century the Bargello, or chief of police. For centuries it functioned as a prison, barracks and place of capital punishment. Leonardo da Vinci sketched Bernardo di Bandino Baroncelli dangling dead from its windows in 1479. He was a member of the extended clan who commissioned the altarpiece and chapel in Santa Croce, but was also the assassin of Giuliano de' Medici in the Pazzi plot. The last prisoners died in its courtyard in the late 18th century – executions were abolished in 1786 – but it continued to be the police headquarters until the late 1850s, after which it was decided to turn it into a museum.

We entered the room on the ground floor in which a grand sequence of 16th-century sculptures is shown, including Michelangelo's *Bacchus*, *Brutus* and *Pitti Tondo*, and Giambologna's *Mercury*. It is a tremendous array of masterpieces, but for some reason to do with the star system followed by most visitors to Florence, it never seems to attract the crowds. After a while Philippe focused on the reliefs and carved plinth of Benvenuto Cellini's *Perseus*, the principal bronze figure of which we had been looking at the day before in the Loggia dei Lanzi, on the way back from Santa Croce. At the time, we had discussed what we were really looking at: the original, or (as is obviously the case with the replica of Michelangelo's *David*), an imitation.

Florence is like that; as Philippe noted – in fact, lamented – it is hard sometimes to tell the one from the other. This is a sign of something else: in the Bargello we are standing in a museum within a larger museum. To an extent, the whole inner city of Florence has been museumified.

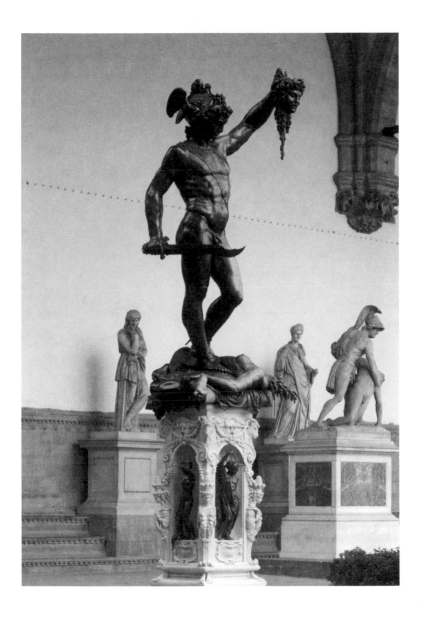

Benvenuto Cellini, *Perseus*, 1545–54

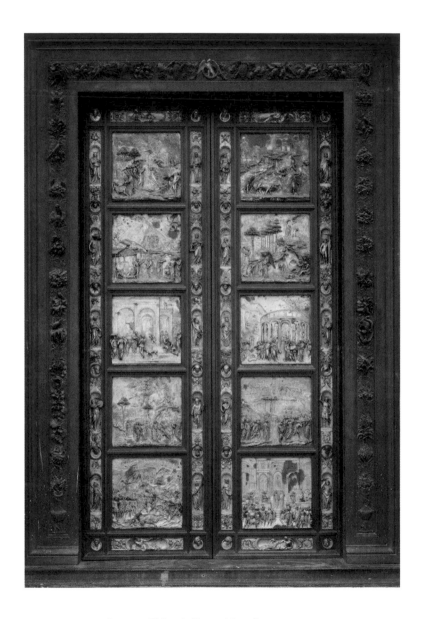

Lorenzo Ghiberti, Gates of Paradise, 1425–52,
Baptistery, Florence, photographed *in situ* in 1970

PdM My more learned colleagues will undoubtedly be shocked at the following, but so be it: in Florence especially, I am troubled by not knowing what is and what is not original or what is the primary version or the replica. That's why I always want the most detailed guide in this city. When we saw Cellini's *Perseus* yesterday, I wasn't sure what we were looking at, exactly, and I not only dislike, but also disapprove of, being unsure. In other words, being put in the position of questioning my own responses because of uncertainty. In fact, the *Perseus* is not a replica, although it is on a false base. It turns out that the base, bronze statuettes and relief are all here in the Bargello.

I find, not being a specialist of the Italian Renaissance, that there is an unsettling element as you walk around Florence. If you do have some modicum of knowledge and pause, say, as you pass Orsanmichele, you think the statue of *St George* by Donatello must be a cast because the original is in the Bargello. But that's not always the case. In this city some of the great works have been replaced in recent years, quite rightly, due to pollution, but then, some have not.

So my peregrinations through Florence today have to be very different from those undertaken in the 19th century when visitors could still look with some confidence at what was before their eyes. Sometimes, you don't even need to see the original and the replica side by side in order to detect the difference. When you stand in front of Michelangelo's *David* outside the Palazzo Vecchio you know it isn't right, but the copy serves a most useful purpose: it gives you the scale and the position of the original and allows you to understand the topography of the Piazza della Signoria, the political centre of Florence as it was in the Renaissance.

The so-called Gates of Paradise by Ghiberti on the Baptistery are also recent replicas, but this does not deter tourists – either unaware or untroubled – from standing in front of them taking photographs.

The spectators are attracted by the fame of a name, paradoxically in this instance by a remark attributed to Michelangelo – that these doors were beautiful enough to serve as the gates of paradise itself.

Meanwhile, the earlier set of bronze doors, also by Ghiberti, is set in place a few yards around the Baptistery. Those doors function as the entry to the Baptistery, and visitors queue up at the ticket office inches away from a completely authentic masterpiece of 15th-century sculpture, but scarcely anyone gives them a glance.

Perhaps, however, Philippe and I are just products of our time in attaching so much importance to the original object, rather than the design, the idea, of the masterpiece – which I suppose you can see perfectly well in the copies of the Gates of Paradise. The people who photograph and crowd around those facsimiles are behaving more like the connoisseurs of the 17th and 18th centuries who saw no difficulty in appreciating a copy of a famous masterpiece of classical sculpture or painting. Charles de Brosses, the 18th-century writer and traveller, said as much: 'I do not fret over acquiring originals by the great masters ... I prefer beautiful copies of famous paintings, available at a price I can afford.'

PdM There is, however, a major difference between a copy made for a specific purpose, such as replacing a work of sculpture to protect it from pollution or the elements, and a copy, often in multiple examples, made to perpetuate an image. That is the case with Roman copies after Greek sculptures, where the originals no longer exist – they were usually bronze and were melted down in antiquity – and where so many are copies of copies and often with many variants. This is a huge and fascinating subject.

After looking at the work of Michelangelo, Cellini and Giambologna, we climbed the steps to the main floor of the Bargello, and immediately Philippe was lured into a gallery with glass cases full of Roman, Byzantine and medieval ivory carvings.

PdM Some of my favourite objects are in this vitrine. There are fantastic things of such sensuality, consular diptychs, Roman and Byzantine works ... there's almost nothing made of ivory that I don't like save those that are carved for sheer virtuosity alone. Let's agree not to

spend time talking about individual pieces; I'll just say that I am frustrated that we can only infer the tactile quality of these objects. We're not living in the first centuries of our era, nor are we collectors of another time, so we can't hold these pieces in the hand and caress them, as they demand to be. Even conservators, today, will handle them wearing latex gloves. Here in the Bargello, I quite like the slightly messy presentation of these ivories, which we almost 'discover' in the case. On occasion, there's something too orderly about modern museums: the object perfectly aligned, pinpoint lit, that bellows out, 'Admire me'.

After poring over those cases for half an hour or more, we went on into the great hall of the building, a grand space that is filled with the greatest collection of 15th-century Florentine sculpture to be found anywhere. The works on display included many masterpieces by Donatello, Verrocchio and Ghiberti. Somehow, the place does not have the feeling of a museum.

PdM When you step into this grand hall you sense that they will have put the best things here, which of course they did. I just love being in this room, I feel as if I am in the crucible of the Renaissance. Is there a room anywhere that has quite so many masterpieces in it? The Bargello is a potpourri of superb Florentine statuary in an almost plausible setting. It's such a mixture but so magnificent. In a way, this is a museum and in a way it's not, because the works are not ordered according to an overt didactic agenda, and also because these works have been brought together in such close proximity to where they were originally installed.

Donatello's *David* over there exudes a sense of total self-confidence in the moment, as does his divine sculpture of *St George*, which is one of the greatest works of art anywhere. Okay, this has been wrenched from its niche on the exterior of Orsanmichele, but from the window we can almost see where it used to be. That makes it easier to understand what Donatello was doing, in terms of the iconography, purpose and symbolism of the sculpture in the city:

St George, the protector of Florence; or, to take another example, why this *David* by Donatello was in the Palazzo Medici, as was his *Judith and Holofernes.*

Scholars have suggested that Cosimo de' Medici put Donatello's *David* and his *Judith* in the Palazzo's courtyard so that visitors would be able to see them as the emblem of the Medici as rulers – the heirs of the Roman emperors. It has also been posited that the Medici were equating their rule with that of those biblical figures who were the saviours and protectors of their people.

That message, which would have been clear at the time, is now lost, not because the sculptures were moved but because the propagandistic message has become irrelevant. We can learn from labels and websites about the context and meaning of such works; but we cannot experience the potent message they were originally meant to convey. Instead, they speak to us through their formal, visual qualities, which in the end may be the most important. Thinking about it, it is for these, far more than for their imputed historical importance, that the works were preserved, and continue to be admired.

MG Historically, I suppose, Renaissance collections, for example the Medici's sculptures and antiquities gathered in their palaces, were the ancestors of modern museums.

PdM Oh, yes, since a collection is the sine qua non of the museum and, of course, many early collections became the first core holdings of museums. Another legacy is the ordering of collections along the lines of the prevailing orthodoxy. The third is public access. That was definitely a factor in the accumulations of objects – both antiquities and contemporary works – in 15th- and 16th-century Florence and even more so in Rome. The antiquities, mostly, were displayed in large courtyards. There was access to the palace itself for people coming on business, with entreaties and so forth. They were pretty much 'public' places, meaning, at the time, accessible to the elite, to the privileged few.

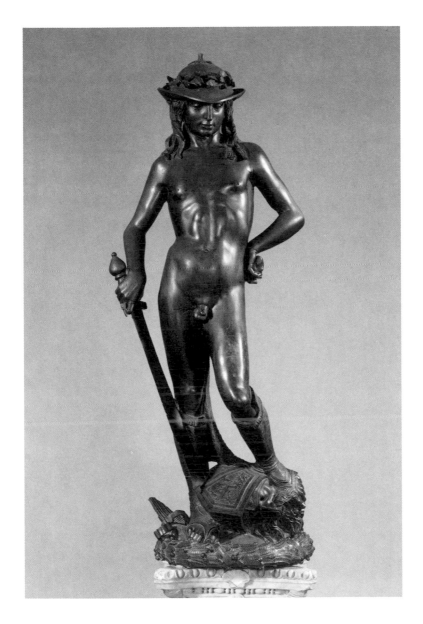

Donatello, *David*, c. 1430–32

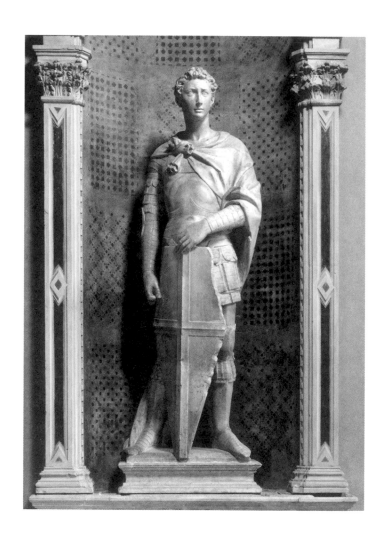

Donatello, *St George*, c. 1416

There were also to be 'public' spaces in the Vatican in the 16th century, when Bramante was asked to design an area for the display of antiquities in the Belvedere, which was incorporated as part of the Vatican itself. That was where the *Laocöon* and the eponymous *Apollo Belvedere* were installed. They were found in the early years of the new century, the *Laocöon* immediately recognized from Pliny the Elder's description, with which humanists, artists and most educated people were familiar. Significantly, it is as a superior and famous work of antiquity that the sculpture was viewed and prized; that it represented Virgil's Trojan hero, punished for having warned of Greeks bearing gifts, was of only secondary importance. That shift in the work's primary meaning is also a precursor of the museum: the aesthetic considerations trumping the original or putative function.

MG That's true. As soon as an object enters a museum, its meaning changes. But arrays of art in the early Renaissance were often transitional. The Medici had the sculpture of *David* by Donatello in the courtyard of their palace partly because of the political symbolism you mentioned, but also because it was a splendid work by a famous artist in an advanced style. It came to be surrounded by classical statues and reliefs that demonstrated the learned taste of the family.

Perhaps the reason why this room in the Bargello feels so right is that although it has a certain rationale – everything in this hall is 15th century – it has something of the character of a courtyard collection, such as the one that was once in the Palazzo Medici.

PdM Another factor is that they are not lined up. Elsewhere, everything is in neat rows, as they are in the Uffizi, for example. Here it is a delightful jumble.

A Sense of Place

PdM Does simply being in the city where the art was made make a difference? A question that arises not just here in Florence, but could as well be asked in Paris, Rome or Bruges. This morning, in the Bargello, even though many of the sculptures we saw were originally placed elsewhere in the city, it somehow seemed that we were looking at them with a Florentine eye. After a few days in Florence, one is imbued with a sense of the place, its aura, its flavour. This is all the more so when the association of art and city, the density and visibility of the monuments, is especially high. Which is why I mentioned Rome and Bruges.

MG Sometimes, during the Venice Biennale, I have wandered off to visit the 15th-century church of San Giobbe. No one much goes there, it's at the far end of the Cannaregio canal in an unfrequented district. And it's rather a poignant spot, because inside you can see the original, beautifully carved, frame of Giovanni Bellini's San Giobbe altarpiece. The picture itself is one of the most famous works of the early Venetian Renaissance. For a long time it has been part of the collection of the Accademia Gallery in Venice, where thousands of

visitors pass it every day. It's hard not to feel it's been torn out of its natural context.

PdM That's very true, of course, but there are other factors involved here and we can't presume every such transfer is gratuitous; often there are issues of preservation and conservation, to do with moisture in the building, burning candles, security from theft, which make it problematic to be too categorical. Also, we have crossed the Rubicon, where a far more secular-minded public values these works more as art than as cult objects, and this is the case even when they are still in churches. Many people now enter churches, in Venice say, as they would a museum, and indeed the first brochure you pick up is more likely to be a guide to the art works than a missal or hymnal.

MG If you had dictatorial powers over every museum in the world, is there anything you would move from its current place?

PdM There are many examples, assuming they're in the vicinity. I would not upend the vicissitudes of history and start to dismantle collections and move objects long distances. These have many lives and each moment of these lives meant something; once it had a purpose. In any event, you asked a purely hypothetical question, to which my answer can only be a fantasy; there are so many political, legal, and even practical, issues involved here. So, playing the game, I would start with Venice and Milan and I would take a number of things out of the Accademia and the Brera and move them not far away, back to where they were initially. This wouldn't deny visitors to those cities access to those works, and it would give them a better sense of their original function and context. What we must understand, though, is that in our museum age, we have developed a museum 'gaze' (a poor equivalent of the French word *regard*) whereby we now see religious pictures (that is what would be involved in this scenario) as part of an art historical, chronological narrative, a history of style, with an emphasis on the artist, the maker. The altarpiece we replace in its

church would recover its architectural context, up to a point, but not so much its religious context since the intensity of faith has decreased and the painting's value as explication of the Scriptures to a mostly illiterate congregation has gone.

MG However, perhaps you pay more attention to a work such as that because you've made a special journey to see it?

PdM No question of that, and we're back to the matter of time. As the object or painting is the one thing we came to see, and for which we made a special effort, we will linger.

MG Titian's *Assunta* is a wonderful example, because the composition of the painting echoes the curves of the Gothic vault above. Thus it can only be fully experienced on the high altar of the Frari church in Venice, for which it was originally painted. You feel it's always been there, but of course it hasn't.

PdM True, since for a hundred years it wasn't in the Frari at all; it was moved to the Accademia in the early 19th century by the French in anticipation of its being taken to the Louvre, but then came the Congress of Vienna after Napoleon's defeat, and the painting ended up in Vienna after the Austrian occupation of Venice. When Venice became part of unified Italy in 1866 it was returned, not to the Frari, but to the Accademia. After the First World War the painting was reinstated on the main altar of the Frari. Works of art can have many homes, many lives.

MG They travel from places of worship – churches, mosques, temples – to museums, and sometimes back again. I confess I would in part, at least 50 per cent, like to see Bellini's altarpiece back in San Giobbe.

PdM So would I. As Paul Valéry lamented in 'Le problème des musées' as far back as 1923, we've stripped the object of its mother,

Titian, *Assunta (Assumption of the Virgin Mary)*, 1516–18,
Church of Santa Maria Gloriosa dei Frari, Venice

architecture. Exhibitions and installations often try to reconstruct it, but many altarpieces still lack a level of meaning, precisely because they were not conceived as independent, stand-alone panels. The picture, the frame, the surroundings were an integral part of the composition. There are numerous examples where the perspective and the light, the floor tiles, the disposition of the figures – everything is constructed to interact with the surrounding architecture.

The same is true of the three pictures by Caravaggio in the Contarelli Chapel of San Luigi dei Francesi in Rome. In creating the sources of light in the three pictures, Caravaggio took into consideration the way the actual light penetrates the chapel itself.

However, on the matter of moving an altarpiece back into a church, this is no more than just a spacial re-integration, for the temporal element has been lost forever. We are not 15th- or 16th-century Italians and cannot ever imagine what it was like to live in northern Italy in that period.

The point has been made on many occasions that there is a cultural *modus vivendi* about museums: in other words, a whole approach to the works within that is distinct from other places, one that fosters the museum gaze I just mentioned. That gaze is so pervasive in our time that we actually carry it with us into non-museum spaces, even churches. Take, for example, the thousands who walk into the Frari to look at Titian's great *Assunta* and his Pesaro Altarpiece; these people are not coming to receive Communion. They are coming to look at masterpieces of the 16th century.

MG It's true I would love to see Bellini's altarpiece in San Giobbe because I feel it would be the best place to appreciate and understand it as a work of art. I'm thinking about it from an aesthetic point of view, and so viewing the church as a huge museum exhibit.

PdM I couldn't agree more, I think that's absolutely the case. There is a photograph by Thomas Struth of the church of San Zaccaria in Venice, with a Bellini altarpiece. There are people standing in front

of it, clearly not in prayer, but appreciating its intended architectonic presence.

MG The works we are talking about are what in contemporary art we call site-specific. That's true of many great cycles of paintings: The Michelangelos in the Sistine Chapel, the Raphaels in the Vatican Stanze, the Mantegnas in the Camera degli Sposi in Mantua …

PdM That kind of ensemble can't be reproduced. Perhaps, for a younger generation, the new, amazingly elaborate three-dimensional digital programmes can begin to recreate that sort of environment. But nothing can replace the experience, the very physical sensation, of being surrounded and engulfed in the actual space.

MG And that, except in the case of some relatively recent works, was almost never a museum.

PdM Yes, It was only in the 19th century that objects began to be created with museums in mind, and consequently their presence in a museum today is at least quasi-correct. Among the very first were works such as Théodore Géricault's *Raft of the Medusa*. This gigantic picture was shown at the official Salon with the thought that the state might buy it and then it would hang in the Louvre. So its true context is actually the great halls of the Louvre.

From then on, until today, there have been artists doing things for museums, hoping they end up there, and making installations in museums. But for the most part, these institutions are filled with things that were never meant to be there. So now the contents have a completely different context, or, often, multiple contexts.

MG Quite a lot of people, archaeologists especially, would say that as far as possible objects should be shown in, or near to, their original place of manufacture or display.

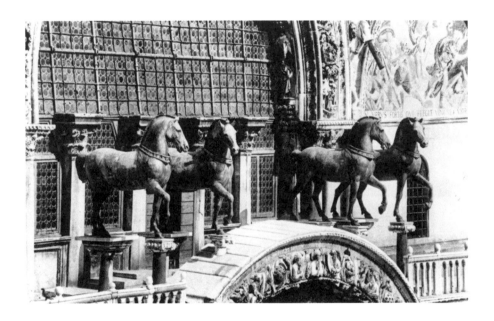

Bronze Quadriga on the west façade of San Marco,
Venice, *c.* 1930

PdM But that is often quite distinct from the 'find-spot', the archaeological site, which is essential for the retrieval of information, especially for prehistoric material where there are no texts. The find-spot is actually the last moment in the life of an object, one of its many contexts. That is the case for buried hoards, for example, which are usually found far from where the objects originated – the result of war or migration.

In the case of the Vettersfelde treasure, to take an example that I know well having negotiated its loan long ago for a Scythian exhibition, it was not examination of the place of the chance find near Berlin that permitted the identification of the objects as 5th-century BC Scythian, from the region of the Black Sea, but their similarity to known Scythian objects, especially those now in the Hermitage. In the case of tomb burials, of course, the last context is usually the most important.

Another contextual issue, rife with meaning, is that of the horses of San Marco and their various and dramatic peregrinations, moving from one triumphant context to another, until the moment when these became but a memory. The horses, generally agreed to be Roman, possibly 2nd century, were taken to Constantinople about two hundred years after they were made, by the Emperor Constantine. For some eight hundred years after that they stood triumphant in the capital of the Byzantine Empire, overlooking the Hippodrome.

In 1204, during the Fourth Crusade, Doge Enrico Dandolo captured the city of Constantinople in a bloody and destructive siege, which saw the melting down of an appallingly high number of bronzes from Antiquity to create cannons and coins. The horses were among the very few works that somehow were spared. They were brought to Venice and placed at first not on the façade of the basilica of San Marco, but in front of the Arsenale, with the intention that they would be melted down. A Florentine ambassador who saw them urged that they should not be destroyed but used in some way by Venice to celebrate its victory over Byzantium, which represented the triumph of Western over Eastern Christianity.

The horses were to leave their perch atop San Marco on two occasions. The first was for another triumphal march, in 1797, when they were brought to Paris as war booty after Napoleon's first Italian campaign and victories in the Veneto, and later mounted on the Arc de Triomphe du Carrousel adjacent to the Tuileries Palace.

The horses of San Marco stayed atop the arch only until the Congress of Vienna in 1815. They were sent back to Venice and re-installed on the façade of San Marco; meanwhile, in Paris, the sculptor François-Joseph Bosio, who had been official sculptor to Napoleon, was commissioned to replicate the San Marco horses, which he did, in 1828.

Paradoxically, it is the genuine horses that ceased being outward symbols of conquest following their second, and final, descent from San Marco in the 1980s. That is when they were moved indoors for conservation reasons, as the gilding and the bronze patina were deteriorating badly in the open air, and they assumed a new role as, primarily, works of Roman sculpture. Copies were erected in their place on the façade.

Although the decision was right, the result, to the eye, is most unfortunate. They look like giant moulded chocolate horses covered in tin foil. All notion of triumph has perished with the simulacra.

Before the horses were unceremoniously taken inside, they actually assumed yet another life, another identity, as protagonists in an exhibition across the ocean at the Metropolitan. There, it was both the art historical context and the romance of Venice that supplanted any sense of triumph or conquest.

MG Now, let me put something to you. You, I know, are often opposed to restitution. Well, then, why don't you lament the fact that the horses of San Marco were returned from Paris to Venice. Didn't that erase a part of their history?

PdM Well, here the crucial factor is one of time. In this case, I think the decade and a half the horses spent in Paris was not long enough to

embed them in French culture, in comparison with the eight centuries they were above the main door of San Marco, the pride of Venetians.

Incidentally, it is interesting that Bosio, even though he enriched the theme of the quadriga by adding a chariot carrying a figure of Peace, ended up creating sculptures so closely associated with their Venetian model that, in my view, they never really acquired an identity of their own as the work of a French neoclassical sculptor. Glance up towards the top of the Arc de Triomphe du Carrousel and it is the horses of San Marco that are evoked. The significance of the Bosio quadriga is hard to decouple from the history of its ancient equestrian model.

The Case of
the Duccio Madonna

It was time to move away from Florence and closer to the 21st century. Philippe had, after all, spent much of his life at the helm of a great institution that was descended remotely from aristocratic collections such as those of the Medici Grand Dukes of Tuscany and civic ones such as the Bargello. The Metropolitan Museum of Art contains numerous precious things once possessed by the merchant princes of New York and presented by them to the institution. Many more have been collected for the edification, pleasure and — let us be frank — greater glory of the city. But the Met, in comparison with the Palazzo Pitti or the Bargello, has grown gigantic and globally comprehensive. Instead of assembling works from one era and one main location, it aims to display the works of all times, places and media.

Philippe and I spent another morning wandering around his erstwhile fiefdom, where as Emeritus Director he is still a familiar figure. As we walked through the door he was greeted with an immediate, 'Good morning, Mr de Montebello' from the attendants (whereas later, in other institutions, to Philippe's bafflement and amusement, his Met Director's card cut much less ice with people behind ticket windows than my press credentials).

Walking around the Metropolitan Museum of Art with Philippe is like being with a film star. In the galleries for Islamic art, which at that time had recently reopened, people walked up to him with the words, 'Mr de Montebello, let me shake you by the hand'. He was the Director of this institution for thirty-one years, from 1977 to 2008. According to Wikipedia, that makes him 'the longest-serving director of any major art museum in the world'.

When I put that point to Philippe, though, rather characteristically he demurred. I was forgetting, he politely pointed out, Irina Antonova, who was Director of the Pushkin Museum of Fine Arts, Moscow, for fifty-two years, from 1961 to 2013. Still, in the international world of museums, Philippe has been a central figure for a long, long time.

When it comes to exploring museums, the Met is not a bad place to start. It is one of a group of five huge institutions spread over Europe and the USA that can claim to be 'universal museums', that is, collections that display all of human culture (or at least a large portion of what can be detached, preserved and put on show). The other major museological mammoths of this type are the Hermitage, the British Museum, the Berlin Museums and the Louvre. Even among these great collections, the Met can claim to be one of the most comprehensive.

Most European museums were born of particular historical circumstances. The starting point for the Louvre was the collections of the Bourbon kings of France, the British Museum was founded by an Act of Parliament, and so forth. Colonial powers of the 19th century controlled specific areas of territory, so their imperial museums ended up having strong collections of art from those places. The Hermitage has magnificent Scythian objects from the shores of the Black Sea, Parisian museums are rich in art from Indo-China, and so on.

In America, as Philippe explains, they do things in their own unique way. It is, obviously, another country, but also one with a crucially different history from that of Europe. Just as American cities are constructed on a rational street grid, whereas European ones have the higgledy-piggledy pattern of things that have grown organically, so the Met has evolved in a manner distinct from its European counterparts.

PdM In Europe, one often has a sense that a selection has been made by paring down a lot of inherited dynastic objects or spoils of colonization or war. Then a curatorial mind has built on that base. In the USA, you start *ab initio*. American museums large and small tend to be encyclopaedic, whether you are in Toledo, Minneapolis, or elsewhere, because they started from nothing, and from the premise that they'd like to buy a little bit of everything: a couple of Chinese things, a few medieval things, and so on.

There are big differences between American museums themselves, but there is also a sameness in their governing principles and the criteria used for acquisitions. One can travel around the USA and one will find pretty much the same mixture of civilizations on display. Where you sense real divergences is in the very large museums: Boston, Chicago, Philadelphia, New York.

Great museums are organisms, constantly changing, and mainly expanding. The collections grow, move in new directions, and, on rare occasions, get sold off; the buildings are adapted and frequently enlarged. Especially in an encyclopaedic institution such as the Met, whole new departments and areas of interest can develop over time. If the public-spirited and cultivated businessmen who founded the museum – it opened in 1870 and its first acquisitions consisted of a Roman sarcophagus and some European paintings – returned today they would be astounded to discover their brainchild not only so rich in major works from so many civilizations that they thought would never be available, but also including among its treasures such things as African and Oceanic masks, costumes and musical instruments.

Like many other museums, the Met has steadily extended the canon: the things we consider worthy of respect and attention. That mirrors the way that Western culture as a whole has expanded its boundaries, learning to appreciate on their own merits objects from much further away in time and space.

A visit to a museum is part of that learning process for members of the public, but so too has working for the museum been a matter of discovering and learning for Philippe.

PdM I have found that when I have forced myself – often with the help of curators – to look at things about which I was indifferent or that even repelled me, I discovered that, with a little knowledge, what had been hidden from me became manifest. I'll give you an example: for a long time I approached galleries of Greek vases with a sense of dread; whether black- or red-figured, the vases all looked alike to me. Museums were often culpable as they tended to show far too many. So I'd walk into one of those rooms, take one look and dash for the exit. But a curator at the Met, Joan Mertens, told me once to go to the vitrines where only fragments, or shards, were shown. She stood beside me and said, look at one of them as if it were a drawing on paper.

I found I was able to look at it this way, forgetting that it was a fragment of a vessel, a three-dimensional utilitarian object. I could focus on the drawing itself, the line, the composition, and how marvellous it was. But the epiphany came when I was able to put surface decoration and vessel shape together, and look at them as one. It is the only correct way, incidentally. In Attica in the 6th–5th century BC the potter was at least as important as the painter. In many instances, the potter has signed the vase as well as the painter. So it was through this complicated process that I was finally able to see how the decoration espouses the shape and how the two work wonderfully together.

Thus, one can be taught, and needs to be taught, how to look, how to put aside one's prejudices, one's overly hasty negative reactions. For me, it was a long learning process, and I have to imagine that for the majority of visitors it can't be easy either. This is why I am so impatient with those who want to position their museum as a form of entertainment. The appreciation of art requires an engagement that is wholly different from the instant gratification provided by most forms of popular culture, and museums have a responsibility to help visitors achieve this.

MG One of the great pleasures of life as an artistic consumer is that of discovery; suddenly finding what other people see in something

Fragment of a kylix (drinking cup), attributed to the Kiss Painter,
Archaic Period, *c*. 510–500 BC

Amphora, attributed to the Berlin Painter,
Late Archaic Period, *c.* 490 BC

that one hitherto couldn't respond to at all. It's a process of enlarging one's sensibility, which is a marvellous experience.

PdM I absolutely agree. We all have a limited repertory of things that we think we like. We gravitate towards those. However, there is a reason why museums have preserved and presented things, and it behoves us to try to understand why. That doesn't mean we have to leave our critical faculties at the door with our umbrella. We have every right to dislike or remain indifferent to certain things, of course, but it is incumbent on each of us to make some effort, at least.

Philippe was in charge of the Met for somewhere between a quarter and a fifth of its history, and was on its staff for forty-two years. A great deal of his life is now embedded in the displays and the collections. As we walked around we were looking at three decades of his decisions and achievements: the galleries devoted to classical Greece and Rome expanded and rearranged, the rooms filled with the arts of Africa, Oceania and the ancient Americas, the magnificent new displays of Islamic art. But how, I wondered, did this mountain of art and artefacts came to be in the Met?

We ended up sitting on a bench near perhaps Philippe's most celebrated acquisition: a small, exquisite *Madonna and Child* by the 14th-century Sienese master, Duccio. It remains the most expensive single object ever purchased by the museum. So how, I asked, did he make that momentous decision to buy it?

PdM When the Duccio was on offer, I had, as Director, to decide whether the picture was worth the huge sum I would have to raise to acquire it. To arrive at this decision, I had to wear several hats all at once: one of these was that of an informed art lover, the French 'amateur', and in that role focus on the seductive and lyrical lines, the harmony of the colours, the felicitous choreography of hands and feet, the wonder of human contact coincident with a certain respectful detachment in the depiction of the figures, that are, after all divine. I also had to don my art historian's hat and note that this Duccio was

one of the very first pictures that mark the transition from medieval to Renaissance image making. It represented a key moment, a break from hieratic Byzantine models to a more gentle humanity.

To be more specific, and it is more than just a recondite detail, look at how the parapet at the bottom connects the fictive, sacred world of the painting with the temporal one of the viewer. This important observation – among others – was made by the curator Keith Christiansen as we were examining the picture in London. This led him to conclude that Duccio must have seen the Giotto frescoes in Assisi depicting the life of St Francis, where the illusionistic framework, including the parapet, relates the narrative scenes to the architecture of the church.

But Martin, you want to know the truth? All those considerations were largely irrelevant when the time came to decide whether to spend in the region of $45 million on the work. For this, I needed my museum director's hat. The quantitative assessment had to be based on different criteria. First and foremost were the old-fashioned notions of quality, craft and skill. Did the work sing? Did it stop me in my tracks and did it then hold my attention? Was I reluctant to turn away from it too quickly?

However, in my mind, the question of relative importance and quality was always pushing itself forward. That the work was beautiful and admirably well painted was not enough. Not in these circumstances. It also needed to be very important, exceptional in every way, and extremely rare. If there had been three or four others similar to this one it would have meant this picture should command a lower price.

Then there was the question of what the price of this panel should be in comparison with one of the missing predella panels from Duccio's *Maestà* in Siena were it to come up for sale. This is because the *Madonna* was and is a self-contained, independent devotional image; it doesn't belong to a larger work, the wholeness of it is part of its beauty and impact. The entire story is there in that one painting. That, too, added to its value.

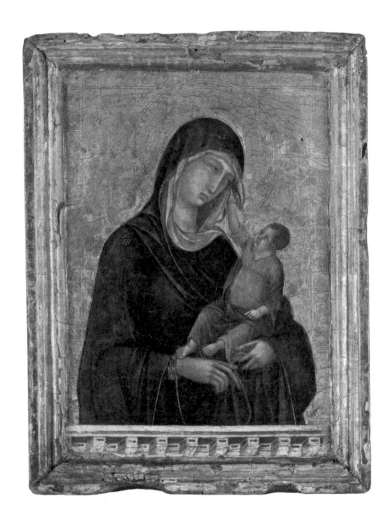

Duccio di Buoninsegna,
Madonna and Child, c. 1290–1300

Then, as curators, we also needed to be concerned with the physicality of the work. After all, this object, which can be held in the hand, has weight and a certain thickness, and is vulnerable to the vagaries of time. Part of what drove me to buy the Duccio was the fact that for close to an hour I did hold it in my hands, that I did turn it around, looking at the back, sensing its weight, measuring its thickness. It had a corporeal reality that was almost, to use a paradox, mystical.

No longer bound by the image alone, as one would be when looking at a photograph – or even from a distance – I then focused on the deep burn marks at the bottom of the frame, obviously made by votive candles, confirming that this was indeed a devotional picture. Just a few additional details resulted from close examination, not the least of which was that the picture was in impeccable condition, a rare thing when it comes to Trecento gold-ground pictures, as most works have suffered greatly over time, mostly I'm afraid at the hands of restorers. If you are a student of Italian art, just think of the case of the Jarves collection at Yale, where many of the pictures, early Renaissance works, are now a near-total ruin. We were also able to confirm that this was indeed not an incomplete work, a wing of a diptych for example, as there are no hinge marks, and among other clues, there is a hole at the top indicating that the picture was hung from a hook.

Then, of course, came the issue of the provenance or ownership history, an important preoccupation of art historians for what it may reveal about the work. While it obviously began life as a devotional picture, made for an unknown patron, it eventually ended up in the hands of two major European collectors: Count Grigory Stroganoff at the end of the 19th century, and later, the Belgian financier Adolphe Stoclet, in his Brussels house, which is a masterpiece of the Wiener Werkstätte. Also, the Duccio had been lent to the great Sienese exhibition of 1904 where it was highly praised; indeed, one art historian, Mary Logan (Bernard Berenson's wife), deemed it the single finest work in the exhibition.

In addition, and not a minor factor in gauging the price, was the knowledge that there would most probably never be another Duccio for sale, as this was the only work of his known to exist outside a museum. I also knew – which is why I made a quick and high offer – that the Louvre, the other major museum that did not have a Duccio, was after it as well and was going to make a real effort to buy it.

So some competitive nerve was struck, and thus the need for pre-emptive action. While it may not have been conscious, I think that there is no question that a part of me wanted my institution to own that Duccio – over and above its importance to the proper representation of the development of Sienese art in the Trecento – simply to have it as yet another major work that would confirm the stature of the Met.

At this point, the sum of all the above, which occurred in a rush of sensory and intellectual responses, led to an important psychological factor, which should not be underestimated in such cases: it is that of the curator/acquisitor experiencing what is a quasi-libidinal charge (you might even call it lust, albeit of a high order); the irrepressible need to win; to have taken possession of the object of desire. You can't get away from that. We are all human beings. Institutions are not made just of stone, glass and steel, they are run by people. It is absurd to try to maintain and project total objectivity.

As a result of all these considerations, these thoughts, observations, calculations and feelings, as well as the confidence I gained from the assurances of my learned colleagues, the Met boasts this masterpiece of Trecento painting, while the Louvre, with its outstanding collection of Italian paintings, is still, and may forever be, lacking a Duccio. This actually saddens me, and I hope that a fine Duccio does turn up some day, from somewhere, and they can get it.

But, obviously, such sympathetic feelings did not prevent the Met bagging the last available Duccio *Madonna*. In other words, the picture ended up in the Met for somewhat similar reasons to those that make an entomologist covet a particular beetle or butterfly: it was a rare specimen, perhaps the

last one outside captivity. Plus, and it is an important plus, Philippe thought it was wonderful.

Of course, objects find their way into museums by all sorts of means. People give them or leave them, or accountants do so on their behalf for motives concerned with tax. Sometimes the curators solicit such gifts, alternatively they have offers made that they do not feel they can refuse. All collections end up with more or less stuff — either eagerly bought in the past, or presented gratis in a job lot — that the current director and staff do not value, or, at least, do not have space to show. It remains, perhaps forever, or until a change of taste or the building of a new wing, in storage.

The entry of the Duccio into the Met, however, is typical in one respect. It filled a gap. But because the totality of fragments of which a museum collection consists is potentially infinite, filling that gap has a paradoxical result. This is summed up in an old museum joke: every time you fill a gap, you create two more: one on either side of the new object. Next, theoretically, the Met might yearn, say, for a work by Cimabue, the Florentine contemporary of Duccio. This hypothetical quest, however, would hit a problem. There are no Cimabues left outside museums and churches; in 2000, the National Gallery, London, acquired the final one remotely likely to come on the market.

In the Met Café

We broke for coffee in one of the cafés that are spread around the Met. As we sat down, Philippe pointed out that eating, drinking, socializing, shopping, and even listening to concerts, is part of the 21st-century museum experience. After hearing how the Duccio entered the Met, I was curious to discover how Philippe himself had joined the curatorial staff of this encyclopaedic collection.

PdM At Harvard I decided to major in art history. My minor was Russian; I love languages and speak a few, and I'm fond of Russian music and literature. When I graduated I was awarded a Woodrow Wilson Fellowship for graduate school and I chose the gold-standard Institute of Fine Arts, not least because it's in New York, where I spent my teen years, and I wanted to come back. I love New York. In addition, the IFA had a superb faculty and, in particular, I wanted to study with Charles Sterling, the world-renowned expert on French primitives. Interesting that the term 'primitive' was still being used to refer not only to early French and Flemish painting but also to early Italian, meaning that the Duccio the Met bought in 2004 would have been called an Italian primitive.

Then one day in 1963, Ted Rousseau, the Met's curator of European Paintings, decided that he needed a curator for Early Netherlandish and early French painting, and he contacted Charles Sterling to ask if he could suggest anyone. Sterling, by the way, had been curator of paintings at the Louvre before he came to the IFA, so he was a museum man as well as an academic. Rousseau, whom I knew slightly, called and asked me to come for an interview. We had a long chat in his office about a million and one things, some about painting, some social, some to do with what I was working on with Charles Sterling. Then he said, let's go to the galleries and look at some paintings. He asked me to comment on certain pictures, and obviously I must have said the right things. I remember at one point he asked, 'What is quality?' I thought, Oh my God! That's a tough one. But I am still of the generation that grew up with formalist art history and for whom qualitative judgments come naturally. So then, too, I must have said the right thing for he suggested I come back and meet the Director, James Rorimer, and I was hired shortly after.

The interesting thing about this story has to do with the attitude of the academic establishment towards museums, one that still exists today, though it's not as pronounced. A few days after I'd been told I had the post, I overheard a senior faculty member in conversation with Charles Sterling, who told him I was going to the Met. The response? 'Oh, what a waste!' That said it all: the mistrust as to the seriousness of the museum world, fuelled by a lack of understanding of it.

MG I suppose the fundamental difference between university life and the museum world is that in the latter you are dealing with real objects, members of the public and, it follows, often large sums of money.

PdM That is true, yet all curators in major museums are formed in the same graduate schools as academic art historians. When they move to the museum, there is no sex change, no violence done to the person, but curators do approach art very differently; unlike the academic,

who tends to be quite theoretical, the curator is more concerned with issues of connoisseurship (attributions and authenticity) as well as the physical properties of the work of art. In a museum, one's ideas do not await judgment in a specialized journal; they are immediately put to the test, their practical applications unequivocally measured by the level of enthusiasm or censure, or worse, the indifference of a large and diverse public, including the press. Curators tend to view works of art not as sources for academic speculation, but as the primary evidence about the works themselves. If Alexander Pope will permit, if the study of mankind is man, then the study of art is the work of art. When considering a work of art for purchase, there is no question that the curator views it through a very different lens from the academic. The curator must perforce assign value: art historical, aesthetic, as well as monetary; there is no escaping this, as I stressed when I told the story of buying the Duccio.

MG The conception of art that we have is perhaps one that couldn't exist without the market.

PdM That's a big subject, especially where contemporary art is concerned. I've often wondered where the market fits in: as leader or follower? Take these four elements: the market, the curator, the critic and even the academic; who is following who? The market does tell us what moneyed collectors will pay for a work of art, right across the price spectrum. These figures are not an abstraction; real money changes hands. So, in the moment, it is the market that informs us of the relative value of things – though not altogether in the absolute, as different categories of art need to be examined on their own terms. It would make no sense to compare the price of a Warhol to that of a Chardin, though the disparity is in itself very telling about taste, money and society.

MG The art critic David Sylvester used to say that there were five players required for the art game to begin, not four.

PdM Did I forget the artist?

MG In some ways, in the contemporary art world the artist is the most powerful figure of all.

PdM Even in the past that was sometimes true. Who was the adviser at the court of the Gonzaga? Mantegna. And Velázquez was collector-curator to Philip IV.

Princely Collections

In Florence we spent some time in a sort of pre-museum: a grand aristocratic collection of the late Renaissance and early Baroque, the age that followed Michelangelo. This was an array of art, religious and secular, gathered together from here and there and displayed with the utmost magnificence to demonstrate the owner's wealth and taste.

The organizers of the conference that Philippe was attending in Florence, a meeting of museum staff and patrons, had arranged rather grandly to have dinner at the Palazzo Pitti. Hospitably, they invited me to come along too. Pre-prandial drinks and the meal itself were served in the courtyard behind the palace, and after a glass of prosecco Philippe and I climbed the stairs to the picture gallery, the Galleria Palatina.

PdM We are visiting, basically, a princely palace. The Pitti is the one place in Florence where one isn't stepping into the Renaissance, meaning the Quattrocento. This is a magnificent 17th-century ensemble, although it contains many great 16th-century pictures. It is, in fact, a museological fossil: an almost perfectly preserved aristocratic gallery from before the age of public museums.

Under Grand Duke Ferdinand II de' Medici, between 1637 and 1647, a series of rooms in the palace was arranged as a *quadreria*: a picture gallery to contain some of the most splendid paintings in the Medici collection. The painter and architect Pietro da Cortona created a sequence of extraordinarily ornate ceilings in fresco and stucco work with an overall effect of enormous opulence. Entering the Galleria Palatina is stepping back into a different way of looking at art and the taste of a distant epoch. The paintings become subsumed into a decorative scheme that is itself a work of art.

PdM I love the look of these great palatial galleries, with wonderful marble floors, elaborate sculpted gesso ceilings and brocaded walls on which the paintings are hung three or four high in a highly decorative manner that has greater concern for symmetry and accommodation to the architectural surrounds than for adherence to any art historical narrative.

The Galleria Palatina presents similar problems to those of museums themselves in that it contains many masterpieces, but the sumptuous setting of an installation – the hanging, the ceilings, the *stucchi* – constitutes a creation in itself. And the second can interfere with the first. While I agree with the notion that magnificent surroundings for pictures painted for palaces is absolutely right, the difficulty comes when the works are hung very high. In this room, although you are able to enjoy the pictures on the lower levels, the further up your gaze travels the less you are able to appreciate the works hung there as painting. That is, you cannot appreciate their surfaces, the brushstrokes, the nuances of touch. You are able to see them only as images. I defy you, for example, to say whether that portrait of Henrietta Maria is an autograph Van Dyck or a replica. On the other hand, we can see Raphael's *Madonna della Sedia* over here beautifully; it is on a hinge so that it can be moved according to the direction and intensity of the sunlight, in order to protect the surface from fading. It's such a divine picture.

Never mind the frame, which is too large, too ornate and distracting. What I really love is the intimacy, the affectionate gestures, the

Raphael, *Madonna della Sedia*, 1513–14

plenitude of forms – it's from Raphael's so-called Michelangelesque period – and the way Raphael has so perfectly fitted the figures in a spiral motion to the tondo format; they fill it without an inch to spare. Also, unlike many of his other works where there is, for me at least, more to admire than to love, this picture is unusually lushly painted – and you know my soft spot for luscious paint!

What claims my attention, too, and has always puzzled me a little, is the psychology: both the Virgin and the Child are looking out at us almost quizzically, as if through an oculus, and we feel somewhat intrusive. They are aware of us in a way that is a bit unsettling; the Child seems to shrink from us as he clings to his mother. It is funny how, even though I know my reading is simply wrong – Raphael, painting in the early 1500s, would have had no such intention – I can't shake what I admit is a purely personal response.

MG I'm not sure that is so wrong. Raphael learned a great deal from Leonardo as well as Michelangelo. We know that Leonardo studied real young women and real babies, and what Raphael has produced here seems to me to be a disconcerting blend of naturalism and religious icon. The Madonna seems pretty and human, indeed just off flirtatious, and at the same time she's not real at all, she's a synthesis of classical sculpture borrowings from other art. You find the picture easier to admire than to love; I find it quite hard even to like, though it's impossible not to be impressed by the amazing skill with which Raphael has whisked together limbs, heads and drapery to create a whirling spiral that perfectly fits the circle.

PdM Yes, it completely fills, almost overfills, the tondo. And it's true that the face of the Madonna is more synthetic than particular. She's idealized.

MG ... or homogenized. That was why Lucian Freud hated Raphael. There's no sense of weight, flesh, of the texture of skin.

PdM Perhaps another reason for your feeling is that for us Raphael has lost a lot of his freshness because he was so used, over-used and abused by three centuries of imitation from the 16th to the 19th centuries. In all that time his work was held as the ultimate achievement in art, along with the *Apollo Belvedere*: they were the standards of what constituted great art until the Nazarenes and the Pre-Raphaelites came along (who, as the latter name suggests, wanted to look at the painters who came before Raphael).

MG For Joshua Reynolds or Johann Winckelmann, Raphael ranked above Michelangelo and Titian, and was superior to Caravaggio, who is probably much more interesting to the modern public.

It's as though Raphael was actually used up by all those years of recycling in academic art. Also, I find that complicated frame around the Madonna is a barrier to seeing the painting, and so, too, is the magnificent decor. These rooms are easy to appreciate as interiors, as works of art in themselves, but I have to make an effort to isolate even the pictures by artists such as Titian, who is just about my favourite painter. For me, the Palazzo Pitti is a good example of what quite often happens in museums and art collections: a struggle between the setting and the works that are fitted into it as if into a collage.

——

A few months later, in London, we took a taxi to the Wallace Collection in the West End. The building commands one side of Manchester Square, which in turn is part of that orderly sequence of streets and squares north of Oxford Street that was the dwelling-place and playground for much of titled and wealthy Georgian London. It is a fitting location for one of the world's most unabashedly patrician collections. In the Palazzo Pitti we had looked at a grand collection of the 17th century. Here we were encountering something close to an authentic 18th-century ensemble.

It was the 4th Marquess of Hertford (1800–70) who created the Wallace Collection as we see it today. Effectively French, he was brought

up by his Anglo-Italian mother in Paris and did not visit Britain until he was sixteen. One of the richest men in Europe, he retained his English residences, but lived in the Château de Bagatelle in the Bois de Boulogne and a Parisian apartment.

The 4th Marquess's taste was much like that of the Goncourt brothers: a 19th-century revival of appreciation for the French 18th century. He bought things from that era lavishly: furniture, objets d'art, porcelain and sculpture, as well as paintings. This, then, is a 19th-century Parisian imitation of an 18th-century French collection, painstakingly transferred to London. Nonetheless, these are the finest evocations in existence of the aristocratic world before the revolution of 1789.

We approached the pillared portico, stepped inside and immediately Philippe, gazing at the grand staircase, seemed to feel at home.

PdM I agree with Leo von Klenze, the architect of the Alte Pinakothek in Munich and the New Hermitage in St Petersburg, who believed grand decor to be best suited for grand art.

The impression of palatial grandeur given by the Wallace Collection is not quite so overwhelming as in Von Klenze's galleries at the Hermitage, of which the architect said, 'This museum forms one unit with the imperial residence and has to be so designed and decorated as to present an endless suite of rooms that are luxuriously and elegantly embellished.' But opulent it certainly is.

We were standing in one of the few aristocratic London town houses surviving from the 18th century, but one greatly extended in the late 19th. Its interior, as far as conceivable from the modern ideal of the white cube, is hung with richly patterned and strongly coloured French silk wallpapers, a fitting setting for a collection that is more Parisian than British.

PdM The whole thing is uplifting. It says, 'We're in a different era.'

We walked up to the first floor, past mythological paintings by François Boucher in which the soft-skinned, doe-eyed nudes look as much like parts

of the agreeable ambience of the ancien régime as the gilt-bronze and por-
phyry vase designed by Charles de Wailly on its equally sumptuous pedestal
(and Boucher's nymphs appear about as intelligent as the vase). At the top
we passed through a screen of pillars in richly veined marble, to be greeted
by yet more Boucher. Philippe drank it all in.

PdM I don't find it problematic to have paintings of this sort sur-
rounded by very rich marbles, carpets, gilt and splendid columns.
The aristocratic nature of art tends to be lost in today's open and less
class-conscious society. But before 1900 or so, most art was the privi-
lege of the 'higher' classes.

Briefly, I took issue with this point. After all, isn't a great deal of Old Master
painting – the works of the 17th-century Dutch for example – intended for
solidly prosperous burghers rather than the wealthy nobility? The same was
true of Hogarth's engravings. And was not much religious art and architec-
ture intended to be seen by everyone, even the poor, in churches that were
attended by all ranks of society? Philippe waved my objections aside.

PdM In Rome, the richness of the churches – with their marbles, gold
and malachite – made them the palaces of God, and the patron, of
course, was the Church: the popes and cardinals. Secular patronage
also tended to be princely; it did not come from paupers and only
infrequently from ordinary citizens. The Dutch, who are Protestant
and more a burgher society, are a special case. But there was still an
educational and cultural divide. After 1900 – after the First World
War, actually – everything changed radically.

Next we entered a room full of works by Jean-Baptiste Greuze, of which the
Wallace Collection has almost twenty. Greuze represents a later and osten-
sibly less hedonistic phase of French art than Boucher.

PdM From one epoch to another taste changes dramatically. Diderot
would have gone wild over every one of these Greuzes.

Jean-Baptiste Greuze,
The Inconsolable Widow, 1762–63

To late 18th-century and early 19th-century taste, exemplified by Diderot – who was not only the founder, chief editor and contributor of the great *Encyclopédie*, but also one of the first art critics in the modern sense – Greuze was a far more virtuous and admirable artist than Antoine Watteau, because he touched the heart-strings, while telling improving stories. It is hard to imagine his work, with its combination of moralizing and titillation, ever coming back into fashion.

PdM Nonetheless, while his pictures seem to us a bit languid, senti-mental, even insipid at times, we must remember how admirable are Greuze's portraits – just look at his portrait of the Comte d'Angiviller in the Met – and he is a superb draughtsman; his drawings are still highly sought after today. As for the paintings, I think we rather enjoy their frank eroticism. Look at *The Inconsolable Widow*!

One breast exposed, her clothes in artful disarray, she is indeed an excellent example of having your cake and eating it. We walked on until Philippe fell for an extravagant piece of furniture in the Oval Drawing Room.

PdM I'd like to be writing, seated at this desk by Jean-Henri Riesener; to roll back the top; to sit on an armchair and be transported into an era of unabashed luxury, which is a very politically incorrect remark because, if we were living in the 18th century, while we were enjoying the veneer on the desk, our peasants would be starving on the lands of our château.

The supremely extravagant piece of furniture in question dates from *c.* 1770 and is indeed a sign of precisely the kind of dizzyingly luxurious living that helped to bring about the French Revolution. It is as much a work of sculp-ture or a miniature picture gallery in wood as a a utilitarian object to write upon. Its side and top are adorned with inlaid images of agreeable things. The very list of materials from which it was made reads like a short poem on the subject of luxury and power: oak, marquetry of holly, stained and unstained, walnut, ebony, box, sycamore, amaranth, gilt bronze, mahogany,

velvet and steel. This desk is very similar to the Bureau du Roi made for Louis XVI.

Philippe then turned his attention to the walls, which are hung with yet more paintings by Boucher, but also others by Jean-Honoré Fragonard. After looking briefly at Boucher's *Madame de Pompadour* he paused in front of a picture by Fragonard, one of his most engaging works, *The Swing*.

PdM Well, you know my proclivity for hierarchies, so I'll say right off that this Fragonard is one step up from a Boucher ... it's utterly delightful. The shoe flying off into the air, heading for the statue of Cupid at the side, that enchanting tree so frothy and unlike a real tree: it's all like a *décor de théâtre*, a theatre set. This is a gorgeous painting about having a good time and about which one doesn't have to think very hard, just abandon oneself to the sheer pleasure it provides: a picture I'd have no trouble at all living with.

Indeed, it's a painting that could stand for the light-hearted − some would say hard-hearted − libertinism of the *ancien régime*. According to the dramatist Charles Collé, who kept a journal at the time, it was commissioned by a man at the court of Louis XVI, who wanted a picture of this incident involving himself and his mistress. The first painter he approached declined on moral grounds, whereas Fragonard was happy to oblige. Its original title was *Les hasards heureux de l'escarpolette (The Happy Accidents of the Swing)*. The final clue one needs to its meaning, and to why the man reclining in the bushes is so entranced, is that in the 18th century women did not wear underclothes.

Next door, in the room known as the Study, dedicated to Queen Marie-Antoinette and containing many items of her personal furniture, Philippe stopped before the cases filled with the Wallace's collection of 18th-century Sèvres porcelain, the finest in the world.

PdM These are splendid! This is how I like Sèvres: if you have it, display it and, best, in profusion. Oddly, I find that individually, Sèvres porcelain can skirt vulgarity. There, I've just lost a few friends over that

Jean-Honoré Fragonard,
The Swing, 1767

one! As a group, though, the richness and awe-inspiring perfection of manufacture are dazzling. It is the general effect that was sought, culminating in the fabulous *surtouts de table* or centrepieces for huge dining-room tables. It's a shame when they are broken up for collectors. They are *ensembles*.

We wandered on to the Small Drawing Room, which is devoted to works by the early 18th-century master Antoine Watteau and his imitators, Nicolas Lancret and Jean-Baptiste Pater. It is also arrayed with more extraordinary items of furniture: a chest of drawers by Antoine-Robert Gaudreaus, for example, from the late 1730s, inlaid with amaranth and boxwood and ornamented with gilt bronze and marble like a miniature rococo palace, or a noble tomb.

PdM I love this integration of paintings and furniture, it is all of a piece; Watteau and Fragonard's pictures would have been seen amid such decor in the 18th century, albeit not quite as overwrought as in this 19th-century re-creation. To me, this room is a sort of *Gesamtkunstwerk*. I even love this enamelled almanac from 1741, in part because I am fascinated by its sheer age, as in looking at its listing of a saint or a religious festival for every single day I am transported back into that era. I like the collapsing of time that museums afford.

Look at this little Watteau almost hidden over here, called *Sous un habit de Mezzetin*. It is a small variant of the great *Gilles* in the Louvre, and a wonderful thing. Watteau's followers, Lancret and Pater, are charming painters but their works simply don't have the bite, the inner life, of a painting such as this Watteau or the one over there, *Les charmes de la vie*.

The musician, standing centre stage, reaching high in the air for the frets of the lute, and with one foot lifted onto a stool, has a tension that you don't find in Lancret, for example in the crispness of the hands and the expressive cant of the head. Or look at the young woman playing an instrument to the left, the contraposto of her pose with her head twisted one way, her body another. This picture shows

a typically Watteauesque scene tinged with nostalgia in a setting worthy of Veronese or Rubens, with a marvellous, deeply receding, idyllic landscape. Simply ravishing.

The difference between the good and the great in art is one of Philippe's most constant themes. And of course there is a tension, too, between the ensemble of the room and the way an out-and-out masterpiece by Watteau demands your complete attention. The pictures by Lancret and Pater are just as much bits of furniture as the chest of drawers by Gaudreaus, but the Watteau paintings are much, much more than that: profound meditations on the fleeting pains and pleasures of life.

In the next gallery, the East Drawing Room, filled with 17th-century Flemish pictures, Philippe found an even more striking contrast between the great and the good.

PdM This Rubens, *The Rainbow Landscape*, contains the whole sap of life! It is about the fecundity of the earth. When you look at it, you can hear the snorting of the cattle, you feel the rustling of leaves, you sense the wetness still in the air, and sunshine through it making the rainbow. Look at how deep that prospect of the hills appears receding into the blue distance! Or when you focus on that little clump of trees on the left, you can feel the wind passing through them, the transparency of the air and the light.

The painting is not anecdotal, and yet it is full of incident: the hay carts, the herdsman driving his cattle out of the pond, the ducks on the left quacking at the cows, the man with the pitchfork flirting with the milkmaid who is carrying a jug on her head. There is an overall sense of the grandeur and yet what you can only call the naturalness of nature. It is a combination of an epic view of the landscape and small details that harks back to the work of Rubens's fellow Fleming Pieter Bruegel the Elder.

MG I agree, there's a Shakespearean sense of ripeness and maturity about it. This is Rubens approaching sixty, retired to his country house

Antoine Watteau,
Les charmes de la vie, c. 1718–19

Peter Paul Rubens,
The Rainbow Landscape, c. 1636

in the Flemish countryside but with a new young wife and family. It's a poem to the plenitude, harmony and happiness of the world.

PdM Another supreme picture by Rubens is the *View of Het Steen in the Early Morning* in the National Gallery in London, which is probably from the same year, 1636. It is one of the few works that could hang well beside *The Rainbow Landscape*, because a great picture can often overshadow other paintings. I walked into this room and didn't really want to look at anything else. Now, I turn around and here is a perfectly fine picture by Jacob Jordaens, *An Allegory of Fruitfulness*, but it becomes almost irrelevant in such close proximity to the work of a higher sensibility than his, by which, of course, I mean Rubens.

If the *Rainbow* were not hanging on the opposite wall, I would go up to the Jordaens and think about how fine a painter he could be. How sculptural. How marvellous. But here he seems to be verging on the academic, though he's anything but that really.

The placement of works of art in a gallery, the choice of juxtapositions, all this results in the works being in continual conversation.

MG Or, you might say, in rivalry. In a battle for attention, the great is the enemy of the good. It is an inevitable result of gathering works together that you make comparisons between them, and some overshadow others. That's a process that works in an opposite direction to the richness of a collection such as the Wallace, where every room is a carefully composed ensemble of painting, sculpture and the decorative arts. When you encounter a masterpiece, you want to tune the rest out.

Another point is scale. In the battle for attention, the big can be the enemy of the small.

PdM That's true. In a room like this where there are large pictures, often epic in conception, it's important to make the effort of approaching small works such as this other Rubens; it's a sketch for a tapestry. Look closely, it's quite exciting. In the best of his sketches, you are

watching the artist in the fever of creation: the speed of execution and sureness of touch, the placement of the figures and expression of movement. In short, the imagined composition passes effortlessly but energetically and swiftly into the artist's brush and onto the panel with no loss of freshness from the cortex through the eye to the panel.

Next we came to a couple of rooms devoted to Dutch paintings. These are part of the 19th-century extension of the building, done rather chunkily by an architect not nearly as distinguished as Von Klenze. The designer in question, Thomas Ambler, was heavily criticized at the time, one Victorian commentator wondering whether 'another man [could] be found who would make almost as many mistakes with Doric entablature as Ambler had made with his stuck-on pilasters'. His galleries, however, do the job they were intended for splendidly.

PdM In this room with its top light we are seeing the pictures the way that they were painted and meant to be seen. In the 18th century, Thomas Edison was not yet born and painters saw pictures in real daylight. If we give our eyes time to adapt and our retinas to expand, little by little in natural light these pictures acquire tremendous depth precisely because of the relative penumbra in which we see them.

Pictures in museums are often over lit. Some colours may pop out and excite, but too much light kills the subtle modulations of colour, especially the half-tones; it flattens and deadens paintings. And when it's pinpoint lighting, the pictures look like colour transparencies.

We passed on to the next gallery, dedicated to genre scenes and land-scapes. Philippe was saying how, on the whole, he has lost interest in Dutch art, with the exception of Saenredam, Vermeer, Rembrandt and one or two others, when suddenly he paused and changed his mind.

PdM Entering this room, I saw Jan Steen's *Harpsichord Lesson* on a far wall and decided to skip it. Now we have ended up near it somehow,

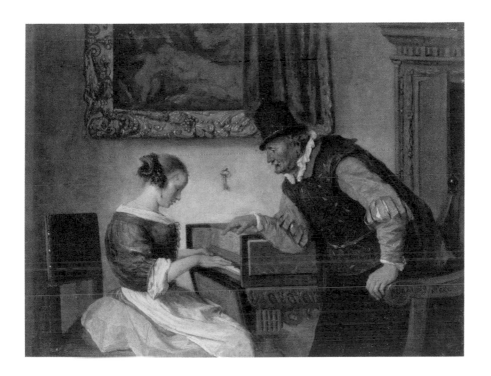

Jan Steen,
The Harpsichord Lesson, 1660–69

I mean, really close to it, a couple of feet away and suddenly the atmosphere has come into bloom, so to speak, and the figures, too, have come to life, emerging out of the light.

Look at the curtain over the picture in the background; these were often hung in front of paintings in the 17th century, not to hide them, but to protect them from the light. It was a good idea, since that is one of the most destructive forces affecting paintings, not only, as is well known, works on paper and textiles.

So we dallied in the Wallace Collection, spending some time with a picture here and there. In front of Frans Hals's *Laughing Cavalier* Philippe shrugged and said, *'I'm happy after twenty-five seconds, but I won't be that much happier if I give it a whole other minute.'*

We considered a Claude, *Landscape with Apollo and Mercury*, for a little while. Personally, I have a soft spot for Claude, a favourite of so many artists from Constable to Hockney, but I had to admit this is not one of his best. Philippe made a point painful to the feelings of patriotic lovers of English art.

PdM I'll take a Claude over a Turner, more because I confess to a blind spot about Turner – I say blind spot because so many people whose eye I respect admire him; so Turner, on the whole, leaves me cold, which is not to say that Claude elates me. Incidentally, I would not compare these two painters, almost two hundred years apart, were it not that Turner himself invited the comparison by insisting that his pictures be hung with Claude's at the National Gallery. Which, to me, was a mistake. And I say this even though I feel that Claude is often too formulaic. On occasion, he rises above the formula, and then you have not only a great Claude but also a great painting.

Philippe is averse to comparing works from different eras, but rightly or wrongly that is exactly what museums and many collections encourage you to do. One could paraphrase Le Corbusier: 'A museum is a machine for making comparisons in.' As Philippe points out, Turner was measuring himself up to Claude – in the same way that many artists of various eras

have attempted to contend with their predecessors. But I entirely agree that he was unwise to do so. When the two are hung side by side, Claude wins.

Downstairs among the Italian Renaissance works, we paused at a painting by Carlo Crivelli …

PdM Berenson wrote about Crivelli, and it struck me as so right that I've never forgotten it: 'His line is like flint.'

… And then Cima da Conegliano's *St Catherine of Alexandria.*

PdM I know Cima is neither Mantegna nor Bellini, by a long shot, still I do love the faces of his Virgins and female saints. Plain, but sweet and sensual. Occasionally, it can be restful to contemplate comfortably, uncomplicatedly, something fine that makes you smile inwardly.

The afternoon passed by easily and pleasantly just looking at art.

An Artistic *Education Sentimentale*

Philippe was born here in Paris on 16 May 1936. His father, Roger, was a painter and art critic. In 1951, Roger de Montebello moved to New York with his wife and four sons (of whom Philippe is the second) to pursue a project that was essentially visual: a form of three-dimensional photography. Educated in New York and at Harvard, Philippe stayed on to make his life in the USA. By now he has become an almost perfectly transatlantic person.

Origins count, however, as was clear when we met in Paris and visited the world's first huge huge and encyclopaedic museum: the Louvre. It contains a peerless collection of French art, and for Philippe – as both a Frenchman and a devout lover of painting – it was filled with personal associations.

This brought out a fundamental point: although the great works in museums are, so to speak, pre-selected for us, our responses are always individual, inflected by our temperament, mood and experiences. Some we always care for, with others we fall out of love, or perhaps never really warm to – except perhaps, one day, suddenly we do. Philippe's itinerary around the Louvre, it soon turned out, was his alone.

After lunch on the Quai Voltaire we strolled across the bridge over the Seine towards the dauntingly vast bulk of the Louvre, then passed through the Porte des Lions, which is one of the entrance passages in the long wings of the building. We were now within the vast embracing arms of the structure.

Architecturally, the Louvre is a behemoth, a masonry monster that has expanded hugely over the centuries. Deep in its bowels a medieval core still survives. It has a Renaissance heart, the Cour Carrée, and a dignified classical face — looking in the opposite direction from where we approached. But the bulk of its giant body stretching towards the Tuileries Gardens is 19th century.

Outwardly it is a vast mass of stonework in the style of the French Renaissance revival; inwardly it is an aesthetic omnium gatherum, a collection of examples of almost, if not quite, everything that might be considered artistically beautiful or significant. Here, brought together in a logical French manner, are objects that in London are spread in a somewhat irrational manner among three large institutions: the British Museum, Victoria & Albert Museum and National Gallery.

Huge crowds gather around the *Mona Lisa* and in the Grand Galerie. However, there was almost nobody where Philippe and I were headed, the upper floor where the main collection of French paintings is to be found. Here it was tranquil: of the 9 million annual visitors only a few had found their way to these rooms. We relaxed and began to look at pictures.

For Philippe, however, these are not just any pictures. Before he was American, he was French (and, I would guess, still fundamentally is so). Therefore, from his point of view these works are not simply paintings; they are part of the artistic history of his country and also connected with his own biography. The display begins with the portrait of a 14th-century king, Jean le Bon, or, to the English, John II.

PdM It's very difficult for a Frenchman to judge this portrait as a work of art, since nearly every single school history book I had from the age of five had this as its frontispiece. So to me this is the start of a great dynastic sequence. But it is, of course, a marvellous picture as well.

Of course, Philippe is not an entirely typical Frenchman, but one who has devoted his life to the study, display, collection and contemplation of works of art. So the pictures in this room constitute an aesthetic equivalent to an *Education sentimentale,* all the more since he was initially attracted to 15th- and 16th-century Northern European painting (which includes France).

PdM There's so much history going back to my very early years, my studies, my first loves in art, that is connected to these pictures. I find it impossible to dissociate myself from that. But part of the life of any work of art lies not only in the work as agent, but also in its reception – in everything we bring to it, me or you, or the reader of our conversations. So here, before *Jean le Bon,* I have to confess to a host of things crowding my mind that I cannot even articulate; a deep empathy for these works that I cannot expect most people to share; it's so intimate, so private. It's a reaction to the work of art that many others have, in their own way. So the magisterial pronouncements of a categorical nature that we museum people are often fond of making should clearly be tempered.

For example, this 15th-century altarpiece, the *Retable du parlement de Paris,* is a work that is very closely related to Rogier van der Weyden and Netherlandish painting. But I'm sure many people, looking at it and hearing me praise it, would say to themselves, 'Yes, but what about the *Descent from the Cross* by Van der Weyden in Madrid, isn't that a much greater work?' What they would not know is that I studied this master in graduate school and was captivated by his individual style, precisely the thing that differentiated him from Rogier.

So, when I look at the paintings in this room, my response directly reflects that important moment in my years in graduate school. The other pictures, on the opposite wall, belong to an extraordinary group of works by the man who was called the Master of Moulins, because in the cathedral in the town of Moulins, in central France, there's a wonderful altarpiece of the Virgin in glory with angels. As is common in art history, a number of works were attributed to

Unknown artist, *Jean le Bon,*
King of France, c. 1350–60

Master of Moulins, *The Madonna Surrounded by Angels*,
central panel of the Triptych of Moulins, 1498–99

this master, based on their similarity to the Moulins painting. So he became known as 'the Master of Moulins'.

When I was a student at the Institute of Fine Arts in 1962–63, Charles Sterling gave a series of seminars on the relationship between the Master of Moulins and the Burgundian and the Netherlandish school, particularly his affinity with Hugo van der Goes. He said one had to be able to find a name for this artist, as he is far too great to remain anonymous, and he played around with two or three possibilities. In his second seminar he felt confident enough to speak of a painter named Jean Hey, and he was becoming increasingly comfortable with the notion that maybe Jean Hey actually could be the Master of Moulins. He wasn't quite ready to say so definitely at the start.

Meanwhile, we were assigned to look and write about many of the issues involved. By the time the seminar ended, Sterling announced that he was now fully convinced that Jean Hey and the Master of Moulins were one and the same, and shortly afterwards he published this important discovery. It was thrilling for me to have been part of that process, and academics aside, I am still an admirer of the Master of Moulins, or Jean Hey. How much of this is owed to my work with Charles Sterling, I don't know, but there is no doubt that my 'gaze', when it comes to Jean Hey, is coloured by this association. I was about to say mine is not here 'a pure aesthetic response', but then, is there ever such a thing? All this means that looking at these works, I immediately conjure up what they owe, for instance, to Hugo van der Goes, an art historical encumbrance with which most people are not afflicted. In the Master of Moulins, I would then venture, the more highly charged temperament of Hugo is tempered by a French sense of clarity and dignity; courtly elegance is expressed with almost archaizing simplicity and surface-hugging compositions that recall stained-glass painting.

And so the anonymous Master of Moulins acquired that indispensable thing for real fame: a name. In the past, particularly the first half of the 20th century, a great deal of effort by great art historians went into sorting

unsigned paintings into groups that – according to looks and style – seemed to be the work of one artist. These hypothetical figures were then given a title: the Master of Moulins, the Master of Flémalle, and so on. Bernard Berenson, who was a particularly fertile inventor of conjectural artists, came up with perhaps the most celebrated, because the most amusingly whimsical, of these: the Amico di Sandro, a painter close to, but not identical with, Sandro Botticelli.

The next move, after this life-work had been assembled and agreed, was to try to give the master a real identity. As it turned out, the group of works ascribed to Amico di Sandro was later shown to be by the young Filippino Lippi. The same has happened, as Philippe explained, with the Master of Moulins. However, in the case of the Master of Flémalle, the attempt to identify him with Robert Campin, concerning whom we have archival documentation but no certain paintings, remains hypothetical (it was rejected in an exhibition of 2009 in Frankfurt and Berlin).

The history of art is, to a large extent – and despite the efforts of scholars who would like to transform it into a study of visual culture – still a story of great names. In the art world, including the art market, the answer to the question, 'What's in a name?' can be, 'an enormous amount of money'. The difference between a genuine Leonardo da Vinci, for example, and an imitation is a matter of tens, if not hundreds, of millions. Consequently, it is disadvantageous for pictures to be anonymous: they get more attention if they can be attributed to a known artist, especially, of course, if he is a famous one.

PdM There's no question about it, and we owe that a bit to Vasari, whose history of art is really a history of stars, as the title says: it's the lives of particular named painters, sculptors and architects.

MG The star system still operates in the art world, both the contemporary one and the market for Old Masters.

PdM Absolutely, here's a case in point. This is a fabulous portrait – *Man with a Glass of Wine*. For a long time Charles Sterling toyed

Nuno Gonçalves(?),
Man with a Glass of Wine, 1460

with the idea that this might be by the Portuguese painter of the San Vicente altarpiece in Lisbon, Nuno Gonçalves. And indeed, here it says on the label that it might well be by Gonçalves, but it also suggests a French artist, with a question mark.

MG So not only is this picture not linked to a particular artist, it isn't even definitely assigned to a country. It's doubly orphaned. Does that actually make a difference to how we see it? After all, Gonçalves is not much more than a name, a painter who worked in the second half of the 15th century in Portugal. That's all we really know.

PdM True, of course, though he has left us a magisterial work in the San Vicente altarpiece. I suppose that it might seem silly of us to bother about who painted it and where it was done. But as soon as you reach a certain level of sophistication about art, then it does begin to matter. At that point it is not just an academic exercise; thinking about attribution starts to affect the way we look at a work and interpret it. We can't, for example, stop the avalanche of other comparable works conjured up in our minds. If you say 'French' or 'Portuguese' you immediately create a whole series of associations.

Beyond these art historical and cultural considerations, it is useful to remember, even before works that are almost perforce anonymous, that at some point an individual made them. This applies to many works from antiquity, or from Pre-Columbian America, and so forth. They may be strongly tied to a set of conventions but they are nevertheless the product of an individual artistic sensibility. I believe a number of museums are now using in some instances the formula 'artist unknown' instead of the former appellation 'anonymous'.

After this, we walked through a door and left the 15th century.

Lost in the Louvre

In *Civilisation,* Kenneth Clark described the modern public as 'the almost bankrupt' heirs of the Romantics. Perhaps that applies to Philippe and me. It was in the later 18th century that educated Europeans began to expect exalted and improving experiences from looking at art.

In the early 19th century, instead of regarding music as a pleasant background to social life, audiences at concerts began to listen in rapt silence as though at a religious service. Visitors to art galleries also changed their expectations. In Germany, experiencing art – and learning about it – were considered part of a person's *Bildung*: that is, intellectual, moral and spiritual development. For the same reason, as the critic Robert Hughes noted, at a certain point 'the Museum began to supplant the Church as the emblematic focus of great American cities' (the mighty Met of Fifth Avenue being perhaps the pre-eminent example of that phenomenon).

Two centuries after the Romantics, Philippe was in search of something similar: the experience of being lost in a work of art. This became clear during our visit to the Louvre when we arrived at what turned out to have been his true destination all along.

PdM In this room I want to stop in front of one picture, and one picture only. Nicolas Poussin's *L'Inspiration du poète* (*The Inspiration of the Poet*), which, along with Watteau's *L'Enseigne de Gersaint* in Berlin, I consider to be among the greatest French pictures of any time. I was going to say produced in France, but this Poussin was painted in Italy.

This is one of the rare paintings in front of which I can almost invariably reconstruct the emotion I felt when I first saw it. Very frequently one struggles to recover that constriction of the heart you felt the first time you saw a particular work, one that you felt strongly about. I find this somewhat dispiriting, although often I have learned to see and appreciate different qualities in these works. But what prompted almost a 'Stendhal syndrome' the first time, seems forever elusive. [The Stendhal syndrome: feeling faint and dizzy from excitement in front of a work of art.]

This picture has never lost its strong attraction for me, perhaps because of its nature; it never strikes like a bolt of lightning. Rather, before it one feels a sense of tranquillity and serenity, poetry and equipoise. As I look at the *Inspiration of the Poet*, I am aware of a merger of the cerebral and the emotional that is truly wondrous.

Standing before this picture I am transported into a world in which the sense of surpassing man and humanity is such that we seem to enter a quasi-spiritual realm. Look at the way the muse's legs are crossed, at her wonderful drapery, the arm of Apollo on the lyre – so natural yet so rife with meaning; and the poet who gazes, inspired, at the laurel wreaths proffered by the winged putto. There is no ostentation, no overt drama; it's a very noble painting, calm and quieting yet deeply absorbing. The picture's impact changes and deepens as you look at it, especially if we take into account its wealth of meaning, its moral authority owing its affective power to the perfect amalgam of the cerebral and the formal.

I felt I was beginning to get a feeling for Philippe's taste. The pictures he is drawn to have a quality of silence and restraint, combined with compelling

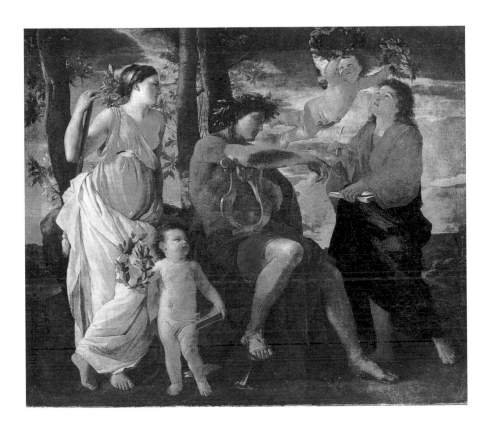

Nicolas Poussin,
The Inspiration of the Poet, 1629–30

Nicolas Poussin,
Vision of St Paul, *c.* 1649–50

naturalism. The Watteau he mentioned is a painting of people looking at paintings: an image of contemplation. The Poussin is extremely classical, but at the same time sensuously naturalistic.

PdM A great deal is revealed by a comparison with Poussin's *Vision of St Paul* on the other wall. It's another moment, another manner of Poussin, and quite marvellous; but for me, it is a bit too much like grand opera. Whereas in *Inspiration of the Poet* there is stasis, gravitas, and an immanence that touches me profoundly.

In front of a picture such as this, and fortunately there are dozens in that class, one feels like exclaiming 'This simply has to be the greatest picture in the world!' That is because, when wholly absorbed by it, nothing else exists; we have abandoned our whole being to that one surpassing achievement. I feel the same way in front of the Ghent Altarpiece and *Las Meninas*, for example.

We continued to look at other 17th-century pictures, though none excited Philippe's admiration to the same extent: the nearest was *The Penitent Magdalene* by Georges de La Tour, a follower of Caravaggio working in the Duchy of Lorraine, now part of France but then an independent mini-state.

PdM Georges de La Tour was sufficiently idiosyncratic, sufficiently personal to move beyond a more conventional Caravaggism towards something more silently spiritual. Like Vermeer, he was little known before critics and historians began to notice him. That was not until 1915, when the German art historian Hermann Voss wrote an article about him. Before that, any picture by Georges de La Tour would have been attributed to the school of Caravaggio.

I think there may have been a need in the east of France at the time of the Counter-Reformation for a certain austerity and spirituality. La Tour's are pictures about silence, too. Look at the flame. There isn't a breath of air; no movement, no noise.

We have to judge paintings, or try to, according to what we understand to be the artist's intent and his style, his manner. Here, if

we were to take the Magdalene's arm holding the memento mori, the skull, and put it in a picture by Georges de La Tour's more academically accomplished but less spiritually probing contemporary, Simon Vouet, the court painter of Louis XIII, you would ask who the studio hack was who painted that wooden arm. But it doesn't matter here. That is how, in his maturity, Georges de La Tour paints, and the manner is coherent, consistent; it becomes an effective expressive tool; it is part of what attracts us to his pictures.

MG Great artists can make us forget their deficiencies. Lucian Freud used to point that out. He had on his wall a painting by his old friend Francis Bacon, *Two Men on a Bed*, one of Bacon's greatest works. 'Look at that leg!' he would exclaim, 'It's absolutely hopeless, but Francis was so brilliant he made you forget all that.' What he said was true, both parts of it. The leg in the Bacon was weakly, almost feebly, drawn, but the imaginative force of the painting was such that you did not notice – or at least I didn't until Lucian pointed it out.

Great artists often make 'mistakes'. Titian and Caravaggio, for example, are full of odd drawing and dislocated space. What makes them great is that you don't notice, it doesn't matter. Like the Magdalene's arm, the 'mistake' seems a natural part of the picture.

Then we went in search of the Louvre's marvellous array of pictures by another great passion of Philippe's: Jean-Siméon Chardin. However, it emerged that the paintings of this supreme exponent of still life were in another wing of the museum. Philippe's back was hurting, I had a Eurostar train to catch. Philippe tends to get pains if he walks long distances (though not, mysteriously, if he plays tennis, which he does by the hour).

PdM One of things I'd like to say is that the reader is hearing the comments of someone who is somewhat physically challenged, whose approach to things is governed to some degree by such questions as: Is he fresh? Is it the start or the end of the visit? As you point out, I have a bad back. My attitude to things varies enormously according

Georges de La Tour,
The Penitent Magdalene, c. 1640–45

to whether it does or doesn't hurt. The eyes are connected to every part of the body, not just the mind.

That last remark is a footnote to a comment often made by David Hockney. He will point out that we do not see mechanically, like a camera, but psychologically. What we perceive is affected by our feelings and our interests. Philippe is carrying that thought a little further, and emphasizing that our response to artistic masterpieces is also influenced by the condition of our vertebrae and our leg muscles. Great museums are not only tiring places, they are wearying in a specific way. There is a certain ache, for example, that could and should be given a medical classification: museum feet.

We were now a little lost in the Louvre in a different sense – searching for the exit from the labyrinth – but eventually we found our way out. En route, back on the lower floor, we passed a room in which perhaps fifty people were standing, arms raised, mobile phones in hands, all looking in the same direction. At first glance it seemed like some weird contemporary religious ceremony, until we noticed that all alone on the other side of the gallery stood the *Venus de Milo*.

Crowds and the Power of Art

Between assignations in art galleries, Philippe and I decided to keep in touch via Skype. We talked while he was sitting in his dressing gown in his apartment on the Upper East Side in New York, sipping early morning coffee, and I was approaching lunchtime in Cambridge, and – important to people such as us who are used to looking – we could see one another.

MG Let me quote something. In his autobiography, *Dichtung und Wahrheit* or *Poetry and Truth*, Goethe described his first visit in 1768 to the gallery in Dresden:

> The impatiently awaited hour of opening arrived and my admiration exceeded all my expectations. That salon turning in on itself, magnificent and so well-kept, the freshly gilded frames, the well-waxed parquetry, the profound silence that reigned, created a solemn and unique impression, akin to the emotion experienced on entering a House of God, and it deepened as one looked at the ornaments on exhibition which, as much as the temple that housed them, were objects of adoration in that place consecrated to the holy ends of art.

Johann Wolfgang von Goethe (1749–1832) was at once a child of what we call the Enlightenment and a precursor of Romanticism. He responded to a 17th-century connoisseur collection of paintings, assembled by the Electors of Saxony, with an emotion that earlier European generations might have felt in church. Goethe lived at the beginning of the age in which it seemed fitting that a museum should be built like a temple.

PdM Although the museum is often like a great temple, that doesn't remove the paradox that a large number of the objects in the museum have been – ugly word – desacralized. It's a temple to culture, but the Baroque altarpieces in museums were once in churches in Rome, Bologna or elsewhere, there to inspire the faithful to piety and for the illiterate to 'read' the Scriptures through the images. The moment it enters this new temple, the museum, the work is secularized; it suddenly ceases to be a cult object and becomes a sculpture or a painting. This applies naturally to any other religious work, whether a Buddha from India or China, or a mihrab from a mosque. On the other hand, if we say the museum is a new temple, it is because we also enter its galleries and approach at least older art with a new sense of quasi-religious reverence.

MG Some would say that putting a religious work in a museum removes its most crucial meaning. It wasn't intended – or at least only intended – to be appreciated as a painting; it was made to be prayed before, to stand on an altar while a priest performed Mass.

PdM Well, the meanings are in danger of disappearing anyway. The modern public by and large no longer reads the Bible, no longer knows the stories represented in the pictures. The role of museums in re-educating people in sacred stories and doctrines is very large.

One could almost make the case that museums fill a gap that the churches are increasingly leaving in teaching the lives of the saints, Christ and the Virgin, plus the stories of the Old Testament. All of the pictures and sculptures in most museums carry a label briefly

telling the story, something that you do not find in church. Walk into a church and you may see a sculpture of a saint, but you won't be told why he is a saint or what he did, if he was a martyr or whatever. Paradoxically, it is the museum that now provides a non-devotional religious education.

MG But the point is that it is non-devotional, offered essentially as an aid to the understanding of art.

PdM That's also part of a wider phenomenon. There's a case for saying that we are in an era in which there is such a huge quantity of images that we have become 'anaesthetized' to them, a word that is the antonym of aesthetic.

In his book *The Power of Images*, David Freedberg describes how in 16th- and 17th-century Rome a prisoner about to be executed had a devotional image, a *tavoletto*, held up to him. It was mounted on a handle and carried before him by a priest as he mounted the scaffold. In a museum that image could hardly have the effect, which it apparently really did have, of soothing these individuals about to go to their end. Freedberg argues that today we are so rational and savvy about art history and iconography that we have become detached.

Two or three years ago in London, Cardinal Cormac Murphy-O'Connor, the Archbishop of Westminster, asked that Piero della Francesca's *Baptism of Christ* altarpiece in the National Gallery be moved to Westminster Cathedral because it was intended to be a religious object and should be experienced as such, inspiring the faithful to piety. Thus it should not be seen in the secular context of the National Gallery. There you have a contemporary example of that claim being made.

MG That point of view is uncommon in Europe these days, which is why the Cardinal's remarks made the news. In other parts of the world it would be more normal.

PdM There is certainly a dichotomy between the Western and Eastern attitudes. The art museum is a completely Western construct. It is a notion that did not exist anywhere else, certainly not in the East until it was 'invented' and exported by the West. All the museums we see cropping up in China, Japan and the Middle East are inspired by the museums of the West. This is not a Eurocentric prejudice, it's a fact.

One reason is that cults and faiths in the East tend to remain much more an integral part of the culture than in the West. *L'art pour l'art* is a Western notion. In the museum in Delhi, you will see that some of the most beautiful early Chola sculptures of Hindu deities are separated from the spectator by stanchions – further than one might wish in order to look closely at the details of the statues, and there are notices urging the visitor not to bring garlands or burn incense: in other words, that this is not a temple but a museum.

MG Conversely, in the great museums of the world – the Uffizi, the Louvre, the Prado – there is now an absolute tide of humanity, so it is like visiting a pilgrimage site, such as Lourdes.

PdM I think pilgrimage is a very good term to use, although I would say that the one enormous difference lies in the voyage itself. In the past, pilgrimage usually involved perilous and difficult travel across bandit-ridden roads through tough and dangerous terrain to get to Jerusalem or Santiago de Compostela.

Museums, on the other hand, do everything they can to make getting there as easy as possible and have multiple amenities in place to make the visitor feel good once there. The art historian Ernst Gombrich once said that the museum tends to kill art with kindness. Of course, that 'kindness', the amenities, operates only when the visitor is inside the museum, otherwise, the hour-long lines that wind around the Uffizi, the I. M. Pei Louvre pyramid or the Prado are anything but kind …

If I did not have the good fortune of privileged entry to most museums, ahead of the lines, I'm not quite sure what I would make of

the experience. It is important, I think, to set up a positive expectant mood for a museum visit, just as sitting in a concert hall reading the programme, watching the empty chairs and music stands, then the orchestra tuning up, and so forth, are a salutary build-up. But waiting for an hour in the cold, the heat, the rain, finally to find yourself, as in the Louvre, completely bemused by that confusing oceanic space with multiple booths, signs and more lines, is not exactly what I would call conducive to a deep, quasi-mystical experience.

MG Recently my wife, Josephine, and I visited the Gemäldegalerie Alte Meister in Kassel. It contains a fabulous collection of 17th-century Flemish and Dutch paintings, wonderful Rembrandts, Van Dycks, Rubens. For most of the time we were virtually the only people there. Admittedly, it was a cold weekday morning in March, with snow on the ground. The attendants followed us from room to room.

PdM I agree, Kassel and Braunschweig are two of my favourite smaller museums.

MG But, isn't the crowding in most museums because they are constantly trying to increase their attendance?

PdM Only up to a point; you could argue that there is a natural audience for most collections. I think many of my former colleagues believe that there is a number of visitors that is logical when you look at the size and demographics of the local population, the tourism figures, and coolly measure the 'repeat visit attractiveness' of your institution – namely the breadth, depth and quality of the collection. The number of visitors is likely to fluctuate a bit according to the exhibition programme, but only a little.

MG Yes, but aren't attendances rising in many places? And aren't directors, and politicians, pleased when they do?

Jean-Siméon Chardin,
La tabagie, c. 1737

PdM Of course, the boards and budget people look at attendance as a driver of income. However, leaving aside the large museums in major urban centres, New York, Paris, London, or those with simply fabulous collections, such as in Madrid or Florence, where attendance has risen to unbearable levels, numbers of visitors are actually relatively stable. The museum world should not be viewed as a growth industry.

Some institutions, with short-term success, but long-term failure and continuing shame, have used every method to increase attendance – most, by definition, if not harmful to the experience of art, distinctly tangential to it. But in my view, there is a fairly constant, plausible visitor comfort level that most museums have reached and it is not likely to change much.

Assuming that someday the problem of getting people in can be solved (most museums have only one or two entrances), then, oddly, numbers can rise if museums find ways to educate their publics to visit more evenly, seeking out the galleries now less popular. As we saw, even in the Louvre, in the height of summer, if you leave the superstars on every tourist's checklist – been there, seen it, and photographed it too – and go to the upper floor, you'll find the galleries with many works by that master of painterly delight, Chardin, well-nigh empty. And yet a great Chardin, such as the justly celebrated still-life *La tabagie*, is about as satisfying and scrumptious a paint surface as exists. In the rendering of simple everyday objects, there is a level of illusionism as well as tactile qualities that are sheer 'magic', the word that Diderot would use to describe Chardin's works.

MG It's true that there are empty galleries in many places. I've often thought that the upper floors of the V&A would make a good location for a murder mystery. A body could lie undetected between the cases of the porcelain collection for hours, even days. But I think there's a difference between European museums, which are usually under national, *ergo* political, control, and American ones, which are often more independent.

115

PdM And I should also mention one of the other main differences between a museum like the Louvre and the Met. The Louvre is host to millions of visitors who are not art lovers, necessarily, but go there because it is on their Paris 'must-see' list, from the Eiffel Tower, to Notre Dame, the catacombs, and the *bateaux mouches* … the Met does not have those buses unceasingly disgorging hundreds of tourists who visit in packs following their guide's little flag and ruin everyone else's experience.

MG But haven't museums always wanted more and more visitors, since they began? Isn't that part of their DNA? After all, why open a collection if nobody sees it?

PdM Well, yes, having visitors and increasing their numbers is embedded in their history. The inherent paradox of the museum is that it was born as much out of a desire to collect and preserve objects as it was to allow access to them. If we go back quite a bit, even to before 1793 when the Louvre opened to the public, back to the 16th century, there was a desire to make antiquities available. Paintings, still for the most part religious, had a specific votive function, whereas it was acceptable to collect antiquities since they had no use beyond being vestiges of a long-lost past, and they became the historical and artistic models that were a guide and inspiration for many centuries.

Many collections were formed during the Renaissance, most notably by the popes, and the wish to display them soon followed. So the popes moved classical sculptures from in front of the Lateran Palace to the Campidoglio, the Capitoline Hill, an action that encapsulated one of the museum's most overt acts of metamorphosis, namely that of desacralizing cult objects.

I don't want to get too professorial here, but we are Skyping and comfortably seated *[Philippe is also puffing on a cigarillo]* so let me skip to the 18th century and suggest that when German princes were amassing astonishing collections, from Düsseldorf and Munich to Dresden, Kassel and Braunschweig, they encouraged visits, albeit

restricted to a very particular public, with the idea that this would show them to be enlightened and, in a competitive way, that they were richer and more cultivated than the neighbouring prince. So access was one of the key factors that led to the conversion of private collections to public art museums.

In France, which was, unlike Italy or Germany in that period, a unified state under an absolute monarchy before 1789, the collections had to be pried out of the king in little bits and pieces, and displayed initially at the Luxembourg Palace. In England, although the British Museum was founded in 1753, at that point it was really no more than a *Kunstkammer*. Its story is a 19th-century one. And it wasn't until late in the 18th century that the great collections in British country houses could be visited.

MG Everybody was allowed in, provided they had the appearance of a gentleman ...

PdM Everybody, still meaning an elite few, and often even an invitation and clean shoes as well; most collections were closed when it rained. You don't want to soil those beautiful parquet floors, do you?

MG So, there were few crowds in the 18th and 19th centuries except for special events with a social cachet, such as the Royal Academy's annual exhibition, which we know from prints and descriptions was packed to bursting in the age of Constable and Turner.

PdM And also the Salons in Paris, so named because these exhibitions were held in the Salon Carré of the Louvre.

In those days, places that are now almost intolerably packed, such as the Sistine Chapel, were virtually empty. Goethe wrote about his visits in the 1780s, and how he tipped the custodian so he and his companions could walk around the high, narrow gallery intended for cleaners and stand a short distance below Michelangelo's frescoes. The critic Robert Hughes recalled

how, in the 1960s, he rode around Italy on his motorcycle and had all the great churches and museums to himself. Now, with the growth of mass, global tourism almost everywhere, those days are gone.

PdM As I said a moment ago, museums have become destinations in itineraries devised by the tourist industry. My predecessor as director of the Met, Tom Hoving, wrote about the six-minute Louvre, in which the tourist raced from Michelangelo's *Slaves* to the *Mona Lisa*, taking in the *Victory of Samothrace* on the way, then out and off to the Arc de Triomphe.

MG One snobbishly thinks of those regimented visitors on tours as being marched through and not having a worthwhile experience. But whether or not they are a representative sample, larger and larger numbers of people everywhere are becoming interested in art, and inevitably that will put pressure on museums.

PdM It is difficult to argue against this of course, and it has to be seen as a good thing. The difficulty is that the population of the world is measured in billions and museums simply aren't set up to accommodate more than a relatively limited number of people. It's in part a matter of square footage – short of going totally digital, you'd need much larger buildings and far more space between and around works of art. Their size also comes into it, many are small, whether statuettes, cameos or pictures. So, if I am standing in front of a small panel by Jan van Eyck, how many other eyes are going to be able to see it at the same time?

MG On a visit to the Hermitage in St Petersburg, there was such a steady succession of tour groups standing in front of Leonardo's *Benois Madonna* that eventually, to see it, I had to squeeze into a little space behind one guide's back. I was close to the picture, but it was hardly easy to concentrate on it.

PdM The result is that one sees things superficially, because fully to enter into a picture's world and allow it to yield its many different layers of meaning requires at least several minutes – and by the way, several minutes is an eternity in a museum. If you stand for five or six seconds in front of something, you have barely begun to scratch its surface.

One inescapable reality about the visual arts that is not shared by the performing and literary ones, is that they can be experienced holistically – taken in at a glance – and not sequentially in time. There is no way in which I can listen to one of Beethoven's Razumovzsky quartets in the equivalent of the glance I might afford a Baroque altarpiece. I am compelled – joyfully – to stay in my seat to listen to all four movements, played seriatim. But the trap, and it is a trap, is that I can look at a Titian and in a blink of an eye take in its superficial aspects – that it's an Assumption or a portrait or the Flaying of Marsyas. But how much am I really seeing? Even if I give it ten, fifteen seconds, before I begin to be pushed by the people behind me, I'm really not seeing that much more.

It's an issue with very large museums in big urban centres, which is why you had such a wonderful time in Kassel. It's often similarly uncrowded in the smaller Italian towns. Unfortunately, many of the finest works of art are in the world's most famous and frequented museums and thus in conditions least conducive to proper viewing.

To me, that's one of the many inherent paradoxes of museums. Great works of art are made available to the many (we can but applaud this) but achieving that magical, individual and silent colloquy between the work of art and the viewer is forever bound to be in conflict with the desire of greater numbers wanting to see that work. I could have said, directed at my museum colleagues, 'the desire for greater numbers', which is not the same, and opens up a discussion not for these pages, but one that needs to take place. I'll admit, though, that this is a conundrum for which I still have no answer.

Heaven and Hell
in the Prado

Months later, when we met in another of the richest collections of painting in Europe – the Prado, Madrid – Philippe went first to an unexpected picture, Antonello's *Dead Christ Supported by an Angel.*

PdM The depiction of grief and suffering in this little devotional panel is simply astonishing; it is, in effect, a meditation on the Passion and you can sense in the head of Christ that last breath he gave to redeem mankind. How can one not marvel at the ravishing calligraphic details in the rendition of the angel's wings, his hair, the tears – the precision of which looks to Flemish painting, while the classicizing figure of Christ looks to Italy and antiquity. How not to marvel at the pellucid light on the landscape with its foreground barren and strewn with skeletons and dead trees; in the near distance, as if signalling redemption, the trees filled with verdant foliage; and beyond, the city of Messina that seems more like the Veneto than Sicily – but then Antonello also looked to the Venetians.

I'm also very fond of Fra Angelico's *Annunciation*, nearby.

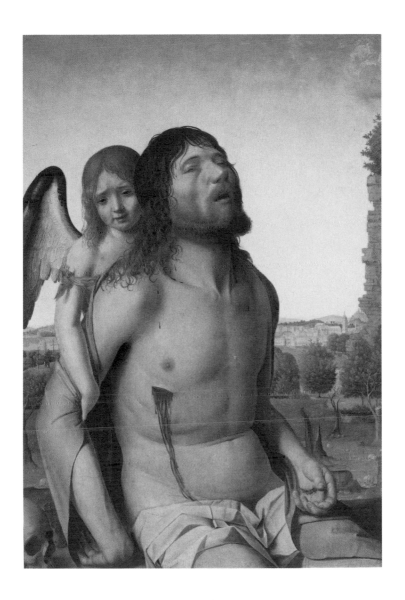

Antonello da Messina,
The Dead Christ Supported by an Angel, 1475–76

Fra Angelico,
The Annunciation, 1425–28

MG Why that picture in particular?

PdM Not because it's the best Fra Angelico, and if I were in the Uffizi or in the Convent of San Marco, also in Florence, there are other works of Beato Angelico that I would have chosen. But we're not, and we're here. Though it is an early picture in which not all pictorial devices such as perspective are fully resolved, there is an honesty, an almost naive candour to the picture that enchants me. As do its clear tonalities, its lyricism and grace; the wonderful bipartite treatment in which both the damnation and the salvation of mankind are evoked. The damnation presents Adam and Eve fleeing Eden against a delicately and meticulously rendered millefleurs-like tapestry of nature that is gorgeous. On the right, within the loggia, in the scene of the Annunciation, is the promise of redemption through the mystery of the incarnation. There is something so angelic – shall we dare to say? – about Gabriel, and the slightly reticent yet compliant Mary interrupted in her reading of the Scriptures. And then, of course, unlike so many mutilated altarpieces, the predella panels are there with their delightful scenes of the life of the Virgin, each a most charming and descriptive independent image.

MG Since Ruskin's time that's been our idea of an angel, not Michelangelo's muscular shot-putter or Caravaggio's street urchin, but a creature with blond hair, pastel robes and wings

PdM But above all, the reason I am drawn back to this Annunciation again and again is that this picture makes me feel good, there's something so serene and uncomplicated about it. I don't believe art has redemptive qualities, but looking at this makes me feel better.

MG We've moved from talking about the visual qualities of paintings – their brushstrokes, the nervous handwriting in paint on their surfaces – to discussing their emotional qualities. How they make you feel. That's something art can do that isn't often mentioned, certainly

not by academic art historians. To talk about feelings would seem unscholarly.

PdM True. And how many art historians or even people with some schooling in art history are among the tens of millions of visitors to museums worldwide? Most people react and 'feel' – or not – in front of works of art. Consider those two Dürers. Why should I be ashamed of turning to you and simply asking you if you have ever seen a better-looking Adam or a more adorable Eve? Of course, I could point out that Dürer had been looking at the *Apollo Belvedere*, and so on. But I'm happy just to enjoy the expression on Adam's face, so sweet, and the way he is holding the apple branch – it is not a fig leaf – with two fingers, as well as the foliage required to cover his nakedness. Dürer has so engagingly endowed his classically inspired figures with tender sensuality; and I love Eve, Venus-like with her pretty Nürnberg fräulein's face. You see: no art history here, just my own very personal response.

MG She looks very German. You can imagine her serving beers. But we've moved from paintings about tragic suffering and loss to one that is frankly sexy.

A couple of rooms away, we came face to face with horror. That kind of savouring of visual meaning and the pleasures to be obtained from brush-strokes, from the creamy application of paint and the exact rightness of tone and colour, turns queasy and uncomfortable when we step in front of one of the most chilling pictures in the history of art: *The Triumph of Death* by Pieter Bruegel the Elder.

PdM It's a picture filled with detail: here is a dog eating a dead baby, there, the figure of death slitting the throat of a man. But it is a painting from which, seductive as the paint layer is, I can't but recoil.

I actually can't look too long at this picture. Bruegel has been so successful in rendering the sheer horror, the agony, the tortures – can

Albrecht Dürer,
Adam and Eve, 1507

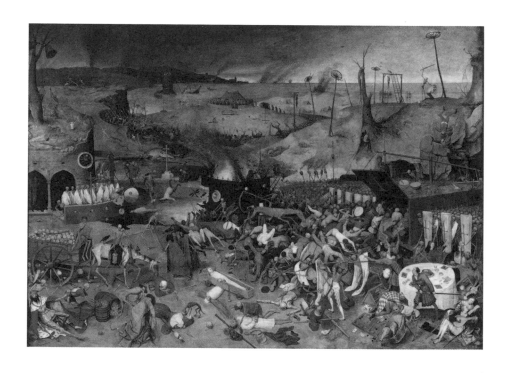

Pieter Bruegel the Elder,
The Triumph of Death, c. 1562

you imagine being broken on the wheel, as those pathetic tattered corpses in the background have been? First, you were beaten, then laid on these wheels, and it took days to die as the birds picked at your eyes. If you look at the chariots being pulled full of skulls, I cannot avoid thinking of the Nazi concentration camps. There is something about this picture, even about its gruesome, almost clinical, realism – which is part of its greatness – and its universality, that makes it impossible for me not to have this somewhat anachronistic response. But then, we are of our own time and we can never shake off its baggage. There is another picture that has this effect on me, perhaps even more strongly, and that is the *Flaying of Sisamnes* by Gerard David, in Bruges. The business-like way the executioners inflict unspeakable pain on the corrupt Persian judge is almost too much to bear ...

MG I agree. I had exactly the same thought. But this is a perfect illustration of the way our gaze is changed by history. Someone walking round the Prado in 1900 could not have had the same association. On the other hand, a mid-16th-century Flemish viewer would very probably have thought immediately of the death squads sent by Philip II to terrorize and exterminate the Protestants of the Low Countries. At precisely the time that Bruegel was painting, his native land was experiencing massacres, judicial murders, show trials. the horrors we associate with the totalitarian states of the mid-20th century and the brutal regimes that still exist in the world today.

Hieronymus Bosch and the Hell of Looking at Art with other People

We entered a gallery that contains most of the greatest work by the Early Netherlandish master of phantasmagoria, Hieronymus Bosch. It was a sight calculated to appeal to a surrealist, and also − clearly − to Philippe.

PdM What a room! We're just surrounded by masterpieces by Bosch.

There was, however, an obstacle to complete enjoyment of this visual feast: quite literally so. As a back-handed compliment to the fame of one of the paintings in this room, the Prado has erected a little fence in front of it.

PdM When you stand in front of *The Garden of Earthly Delights*, as we are now − behind a barrier that is about eight feet in front of the picture − you no longer see a painting. It has become, and I've said it more than once, an image. There's a knot of people in front of this Bosch, just this one, not any of the others.

Hieronymus Bosch

Hieronymus Bosch,
The Garden of Earthly Delights, c. 1500–05

Hieronymus Bosch,
Haywain, c. 1516

This is a work that is pullulating with incidents and chock full of remarkable details, and painted in a splendid, painterly fashion, but you can't see all that because you are simply too far away from it. It's not quite as bad as the *Mona Lisa*, which in my opinion it would be pointless to clean because you can't see it anyway. So why take any risk? It's behind thick glass and a hundred tourists. There's no way of seeing the picture.

You would be much better off in an armchair with one of those books from the 1940s and 1950s with superb black-and-white photos. Or on some of the new websites with wonderful details; I would be perfectly happy to turn to those now, instead of trying to look at Bosch's actual picture under these circumstances.

The Garden of Earthly Delights had only a dozen or so admirers in front of it at that point, but even that small crowd plus the discreet barricade was sufficient to prevent us having the calm, long look at it we'd have liked. Here was a museum phenomenon that we'd come across before: the more celebrated a work, the harder it is to see. But there are, as Philippe went on to point out, some aspects of a painting or a sculpture that can only be properly appreciated in front of the original.

PdM To see how Bosch painted, I turn to the *Haywain*, to which we can stand relatively close. Just look at the clouds, at how they are executed, encrusted almost, with that wonderful creamy quality. If you lean forward you see what you would be able to see if you could do the same thing in front of *The Garden of Earthly Delights*. This picture was conceived by a man of enormous sensitivity and imagination and a very keen mind. There is no such thing as stupid painting that is also good; all good painting is born of mental exercise.

There are, then, qualities in this picture that cannot be reproduced. No printing machine, photograph, computer or LED screen could quite replicate it. The reason is that all the others depend on dyes, in other words, approximations. The pigment has certain physical and chemical qualities

– translucency, thickness, reflectivity – that no reproduction can quite match. A painted copy might capture most of those, but it would still lack the kind of traces that Philippe was talking about: the marks of the hand, nervous brushstrokes, as personal as the timing and touch of a violinist or piano player.

Thus, under ideal conditions, the original work of art offers an experience that is unrivalled. But there's the rub. The conditions have to be right, both for you and for it. That is, it must be accessible and easily visible: not surrounded by a jostling crowd being addressed by tour guides in assorted languages. Furthermore, you must be in the right mood, not tired or distracted, ready to concentrate and with sufficient time – that commodity which, as Philippe points out, we usually do not have enough of when we are actually in the Prado, the Louvre, the Sistine Chapel or the National Gallery. For all those reasons, a reproduction may provide us with a better and deeper experience than the precious, inimitable original.

PdM I have to concede that, when ideal viewing conditions are wanting, which means the un-replicable aura of the authentic being compromised, there are today some high-definition reproductions that can offer much of what the original is no longer able to do, especially when it comes to magnified details where the loss of scale is not an issue. At another moment, when we're comfortably seated, let's come back to this issue.

MG It is a fact of artistic life in the 21st century that most of us spend much more time looking at photographs of works of art – in books, on our tablets, phones and laptops – than we do in front of the originals themselves. And now there are technical tools that let you look at a picture in a level of detail that would be impossible in front of the original: you'd need a magnifying glass and even then you'd probably set the alarm off.

PdM I admit I do find many of these zooming capabilities quite seductive and also instructive. I have even felt guilty at times deriving so

much pleasure from looking at hugely magnified details on the Prado's 'on-line gallery' or the Getty Iris site for Van Eyck's Ghent Altarpiece. I could spend hours on it, and my back wouldn't hurt! But it is a totally different experience from that of actually standing in front of the work itself.

I also thoroughly enjoyed looking at Michael Gibson's book, *The Mill and the Cross*, about Bruegel's *Way to Calvary* in Vienna, discovering in the far distance amazingly well-defined minuscule figures that I had never dreamed were there. I haven't been able check whether the naked eye could actually see these at all or as well. I suspect not. In which case, we are looking at the work in a way the artist did not imagine or intend; but is this a problem? It is, after all, how many conservators, with the use of a loupe or a microscope, look at pictures.

It is an interesting question altogether whether photographs and other images give us a better, worse, or perhaps just a different, experience from the original work of art.

Walter Benjamin's famous essay of 1936, 'The Work of Art in the Age of Mechanical Reproduction', introduced the notion that reproduction of works of art, photographically and otherwise, changed the terms on which we looked at them. The original might retain what Benjamin called 'an aura', but in his view that was a matter of its history, and what he called 'ritual'. The potency of this 'aura' is in danger of vanishing in a contemporary world in which works of art appear in thousands of incarnations on websites, blogs, books and magazines.

On the other hand, there are a lot of people in the art world who would say that relying on photographs is bad practice. Art historians who do it can come unstuck, as the great Erwin Panofsky did in his *Early Netherlandish Painting* (1953). He was writing in the USA, on the wrong side of the Atlantic from most of the pictures, and hence obliged to rely on photographs. The result was some unfortunate mistakes, such as in his interpretation of Melchior Broederlam's *Annunciation*. The Virgin is actually holding a brown taper not a piece of purple wool – consequently an elaborate theory fell flat.

In the art trade there is a proverb, the works that look good in photographs are the bad ones.

PdM So, looking at these very high-quality photographic details causes us to look at the picture in a different way, even when not zooming beyond the eye's capabilities in front of the real thing (the eye does not have a zoom lens); and for a picture such as Bruegel's *Way to Calvary* with so many figures (Vienna's website says more than 500) and so much going on, it is, oddly enough, the early owners who were able to see as much as modern technology now reveals to us. I say this because, if you think about it, when in Rudolf II's collection, the emperor could turn his eye to the picture day after day, getting quite close to it (no stanchions!) and joyfully discover yet another fragment of daily life acutely observed – Bruegel never missed a right gesture or attitude. This cumulative experiencing of the work, in syncopated yet sequential viewing is, in a way, what we all grant the masterpiece that we revisit time and again in a museum.

The diametric opposite, this, to the current vogue for pointing phone cameras at works of art and moving on, waiting either to view the photo at home, or merely to confirm to a friend that 'I was there' … perhaps we should find a way to go back to the habits of an earlier time when the pace of life was also so very different, and look with the care and intensity of our forefathers who often made sketches in a little notebook. In those days, most educated people learned to draw. That act of transcribing what one sees really focuses the gaze. I frequently quote Goethe to my students on the subject: 'Was ich nicht gezeichnet habe, habe ich nicht gesehen' (What I have not drawn, I have not seen).

MG In the case of a great work, it is generally true that the more you look, the more you see. And that every time you gaze at it, you see new and different things. The Belgian artist Luc Tuymans once said to me that one of the characteristics of a truly good painting was that it was impossible to memorize it. A picture like this is inexhaustible.

Of course, what you said about zooming in on a picture is right. The photographic detail has become a natural way of looking at art, in fragments. Book designers like to reproduce a tiny detail, magnified, with the complete painting beside it, the size of a postage stamp.

PdM That's better than the little Skira books that came out in the late 1940s, with illustrations of details and not the whole painting.

MG But all reproductions are going to be wrong because they are physically different from the actual thing in lots of ways. The Ghent Altarpiece is not a glowing screen. Neither is it a sheet of glossy paper with printer's ink on it. An oil painting is a series of chemical layers on a surface, more or less thick, more or less translucent. You could think of it as a solid sculptural object, with certain visual properties, in front of you in a room.

PdM Or, as with the Met's Duccio, held in the hand. But this ideal, personal and physical contact with the work, obviously cannot be widely shared. Pictures are one category of art that resists rather well the rigid, fixed and uncomfortable viewing experience in a museum. Other media, much less so. Looking at drawings in a museum study room, seated at a table, handling them one by one in their mats, is immeasurably preferable to seeing them lined up in frames and screwed to the wall in rooms. This is why I have always enjoyed the practice, set I think by the British Museum, but only sporadically followed elsewhere, of having a railing waist-high in the galleries so that the visitor can lean forward comfortably, resting his or her elbows on it, and spend time with each sheet of drawings.

We are compelled to look at so many other art works without the tactile experience they require; medals, plaquettes, statuettes, and so many more small objects that beg to be held in the hand, caressed, turned round and so forth. And how many visitors cannot resist, when the guard's back is turned, passing their hand over a polished marble statue?

You just know Cardinal Scipione Borghese passed his hands over Bernini's *Apollo and Daphne* to feel its different textures virtually every time he walked passed it. A few generations later, based on what is known of Pauline Bonaparte Borghese's husband, Prince Camillo Borghese, I'd wager Camillo's hands spent more time caressing Canova's marble statue of Pauline as Venus Victrix than Pauline herself.

MG Then there is the matter of colour. An artist I was talking to the other day was saying that black-and-white illustrations don't falsify works of art as badly as colour ones do. The colour is always wrong, and so, even more certainly, is the scale, and scale is always important to a picture's effect. As Cézanne pointed out, a kilo of blue is bluer than a little speck. Naturally, the texture is changed in a reproduced image. So a photograph systematically and in every way subverts the intentions of the artist.

PdM There's an argument about black and white versus colour, favouring the former, but it's flawed. Both traduce the work. Black and white can't be accused of hyping the reds and fading the yellows, but it reduces the work to its light and dark values, and eliminates the whole notion of colour. I admit, the colour reproduction probably sins more acutely because to the innocent viewer its pretentions are higher. You might imagine you are actually seeing the work of art as it really is. When you are looking at black and white you know it's not really like that.

Titian and Velázquez

We walked upstairs and along the central upper gallery of the Prado, which is not quite so long, nor quite so grand, as the Grande Galerie at the Louvre, but similar and also overpoweringly crammed with masterpieces. Walking down such a space, comparing and contrasting the pictures on the walls, is a quintessential experience in the 18th- and 19th-century picture gallery.

PdM One of the consequences of our museum-age gaze is that we have learnt to look at works of art comparatively. I am always stopped in my tracks by juxtapositions such as this where an artist has created his own variant on a theme, here Titian and the Entombment. I don't think it is possible in this case to look at one painting totally independently of the other, somehow one is drawn to engage with both and to look for the differences. The first is earlier and more finished – although it's still a relatively late Titian, dating from 1559.

The body of Christ has weight and substance and is the equal of the finest classical statuary, yet the flesh is soft and limp in death, and the skin seems to glow in the half-light. Everything in the scene – the sarcophagus, the textiles, limbs and faces – is perfectly integrated by light and brushwork into a harmonious whole.

Titian, *The Entombment of Christ*, 1559

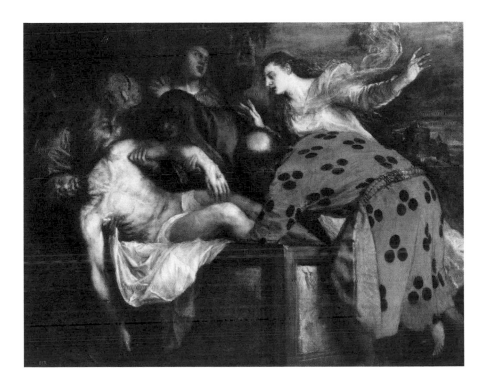

Titian, *The Entombment of Christ*, 1572

Then you turn to the second picture that is even later, dated to around 1570, unfinished, and not in such good condition. Although the composition is almost identical, the brushwork and the drawing are looser, and the mood is very different. It's more sombre. Instead of the rich red robe the figure on the right – perhaps Nicodemus – is wearing in the earlier work, here it is a patterned but dull brownish hue. In this *Entombment* there is an almost aggressive, operatic character to the grief of Mary Magdalene, greater intensity, and Christ is somehow less noble in a classical sense, more obviously dead, cadaverous. Much has been written about greater studio participation in the later version, but here I prefer to focus on the different emotive affect of the works.

MG So we have in front of us an exercise in comparative connoisseurship and art history, and also a lesson in how a great artist, by slightly modulating his approach, can utterly transform the resulting work. Before museums existed, that kind of comparison is something you could only have seen in the artist's studio. Where else would you have two versions of the same work?

It would have been an unusual collector who wanted to own two similar versions of the same subject by the same artist, as Philip II did with these two Titian *Entombments*. In fact, it seems likely that he came by them both partly by accident. The earlier painting was always intended for him, and delivered to Madrid in 1559 (together with the two ripely erotic mythological paintings, *Diana and Callisto* and *Diana and Actaeon*).

The second *Entombment* seems to have been one of those pictures that hung around in Titian's studio for a long while; Vasari saw it there as early as 1566. Apparently it ended up in the collection of a man called Antonio Pérez, and passed to the king after his death in 1585. Philip later sent it to the Escorial, so it seems he did not want two similar Titians to hang next to each other.

Now of course, books, websites and photographic reproductions make this kind of comparative looking normal, though even in the 21st century

you have to go to a great museum to see two such works side by side in front of you.

Now, thanks to Philip and his father, Charles v, who both kept the painter on a retainer, the Prado is fabulously rich in the works of Titian, far more so than any church or collection in Titian's native Venice.

We stepped a few paces down the gallery, and stopped in front of another of Titian's late masterpieces, *St Margaret*, dated 1554–58. It contains a wonderful flickering lagoon landscape in the background behind the saint and the dragon.

PdM This canvas puts in context 19th-century painters such as Turner whom we admire for their so-called freedom. Even Turner doesn't approach the way this view of Venice with the lagoon is painted. It seems to be on fire! In terms of brushwork it is as free as anything you see in any period.

Perhaps John Constable is even more relevant than Turner. We know Constable revered Titian because he gave lectures on art that discussed the work of his predecessors – Rubens, Claude, Poussin and Titian. He devoted eloquent praise to Titian's work, dwelling especially on a piece that he never saw: the altarpiece of *The Death of St Peter Martyr*, which was in the Church of San Giovanni e Paolo (and which, as a matter of fact, we can never see either because it was destroyed in a fire in the 19th century, before it was even photographed).

In a way, Constable had a museum-age gaze; that is, he thought of his own art – painting – historically and comparatively. However, he had a problem: he lived right at the dawn of the actual museum age and never travelled outside England. The first public art museum in Britain, Dulwich Picture Gallery, opened when Constable was already middle-aged. Consequently, his opportunities to see Titian's painting in the original were limited.

One marvellous Titian that he definitely would have been able to look at in the original was *The Death of Actaeon*, then in a private collection in London. This of course is one of the most astonishingly free of all Titian's late works, partly because it was unfinished. An abstract painter friend of

141

Diego Velázquez,
The Surrender of Breda, 1635

mine once pointed out admiringly that Titian almost seemed to have thrown the paint at the canvas in some places. And Constable's own late works are almost Pollock-like in their wildness.

To me, at least in certain moods, Titian is the greatest of all painters. But not to Philippe, who was now keen to stand in front of the works of his own personal nomination for that position: Diego Rodríguez de Silva y Velázquez. If the Prado is extraordinarily well stocked with the works of Titian, it has a near monopoly on the output of Velázquez. True, some other museums, for example the National Gallery, London, the Kunsthistorisches, Vienna, and the Met, New York, have a respectable array. But really, you have to come to Madrid to see Velázquez, who spent most of his career as a servant of the Spanish king.

We began in front of one of those phenomenal pictures (Velázquez painted several) before which, as Philippe says, you begin to think that this is just the best painting that exists: *The Surrender of Breda*.

PdM When you see *The Surrender of Breda* in the original, what you understand – and you don't get in any book – is the scale. The figures in reality are slightly larger than life-size. It remains one of the great monuments of narrative art, and like everyone else I am completely taken by the superbly rendered benevolent gesture of one nobleman towards another, victor towards vanquished, all brought out against that light that strikes the soldiers standing behind in their pale blue uniforms. Then one begins to travel through the picture, and to look at the boldness of so much of it, such as the enormous horse seen from behind; and so many figures seen from the back; while others, far left and far right (perhaps a self-portrait) engage us with their stare – all devices to make us active participants, or at least more than passive viewers of the scene. Then there is the subtle arrangement of the lances; this did not escape early commentators on the picture, which has long been known also as *Las Lanzas* (*The Lances*).

I find it very hard to talk about Velázquez; he strikes me dumb – because he was a painter of miracles, the miracle of converting paint into life, into 'truth', as a visitor to a display of paintings at the

Pantheon in Rome, in 1650, exclaimed about Velázquez on seeing his portrait of Juan de Pareja, now in the Met. There, this is life!

We stood for a while in front of *The Surrender of Breda,* just taking it in.

PdM Velázquez, like Rembrandt, must have loved the act of painting, which is why it is hard to understand why at the end of his life he basically abandoned painting in order to serve the king, for which he was awarded the Order of Santiago.

MG That's one point about Velázquez, he was a great painter whose sensibility was formed inside this collection.

PdM Yes, and he himself, as advisor to the king, helped to build the collection.

Velázquez did something quite odd for an artist: he became a sort of predecessor of a museum curator, spending much of his time adding to the Spanish royal collection and installing it in the king's palaces. The art historian Jonathan Brown has written fascinatingly about this subject. So Velázquez himself, in a way, was one of the first artists to have a museum-age gaze. He spent his life – or a great deal of it – in the very collection we were now walking around in the Prado. His education as a painter came as much or more from the pictures he could see there, especially those by Titian and Rubens, as from his actual master in Seville, a minor provincial artist.

Thus Velázquez became a part of a conversation between painters down the centuries. He was looking and learning from the great masters who came before. Francisco Goya, who was painter to the king of Spain over a hundred years later, was surrounded by the works of Velázquez, who also had a tremendous impact on Edouard Manet when he visited the Prado in the mid-19th century. So there's a line of painters – one of the most important in Western art – learning from this collection, indeed in two cases virtually living in it. Manet was in my mind at that moment, because just before I flew to Madrid I had been looking at, and writing about,

a large exhibition of Manet portraits at the Royal Academy in London. In the catalogue there are some vivid quotations from Manet's letters, giving his reactions to the Spanish paintings he saw on his visit to Madrid in the 1860s. So I am looking at the Prado, today, a little through Manet's eyes.

Las Meninas

We walked on a little, and found ourselves in front of Velázquez's *Las Meninas*, which is often a candidate for the greatest picture ever painted, a category for which Philippe likes to consider nominations. It is a depiction of an apparently trivial, passing moment – the king and queen interrupt a sitting – that seems to go to the heart of the mystery of art: appearance and reality. The writer Michael Jacobs liked to quote a marvellous remark about the painting that he remembered from an art history lecture, 'nothing is happening, but everything is happening'. This is one of those great works that, however often one has seen photographs of it, always seems much more powerful and somehow different when one stands in front of the original.

PdM Even assuming that an identical, a clone-like, reproduction of a work of art could be achieved, it would never supplant the original on which it was based, for it would lack that one crucial element, namely authenticity. Let me give an illustration (no pun intended). In standing before *Las Meninas* here at the Prado, leaving aside all the historical and art historical data that accompanies one's appreciation of this consummate masterpiece, the visitor derives much of his thrill, in addition to his apprehension of the sheer beauty of the

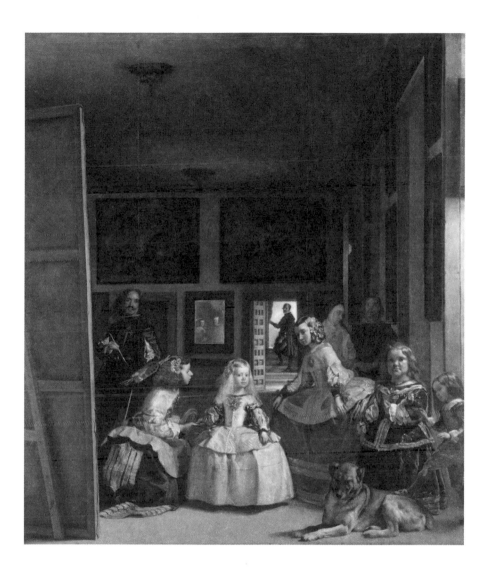

Diego Velázquez, *Las Meninas*, 1656

Diego Velázquez,
The Jester Sebastian de Morra, c. 1646

work, from his firm belief, his total and utter confidence, his absolute trust, that the canvas before him is the one that Diego Velázquez painted; the very one before which the explosive force of his creative genius transformed pigment into a miracle of painterly verisimilitude. The thrill also comes from his complete trust in the fact that this object, and not another, not its clone, either on the museum wall or in a cyber-museum, not anything else, is the object before which Philip IV himself stood in admiration some three hundred and fifty years ago. That magic of the original, the authentic, is what the museum can never lose because the public will always demand it.

One further word on reproductions: it has been predicted that future generations will find the computer screen so thoroughly seductive that if ever technology permits the creation of perfect replicas, people will no longer make the distinction between original and reproduction; or even care. I think they will.

But here we can do better than be conjectural. The founder of Microsoft, Bill Gates, has given us tangible proof of how the distinction between original and replica can be clear for even the most technologically oriented person. For a few dollars, Gates could have made an excellent facsimile of the Leicester Codex by Leonardo da Vinci. Instead, in 1994, at the very time he was trying to put together Corbis, a vast digital archive of works of art around the world, he paid just over $30 million to have the original. That is very telling.

Philippe and I went on through several galleries and stood in the amazing room where Velázquez's portraits of the court dwarves and jesters are hung. We began with *Sebastian de Morra*. Philippe's enthusiasm was, if anything, even more intense than it was a few minutes before when we were in front of *The Surrender of Breda*.

PdM The humanity, the dignity of this man! Also, show me a flaw, a stroke of paint, a highlight that's in the wrong place. You can't. Velázquez was a god. Sebastian de Morra is there, starring fixedly at us and past us, but he is there, now, in our space, as alive as he was

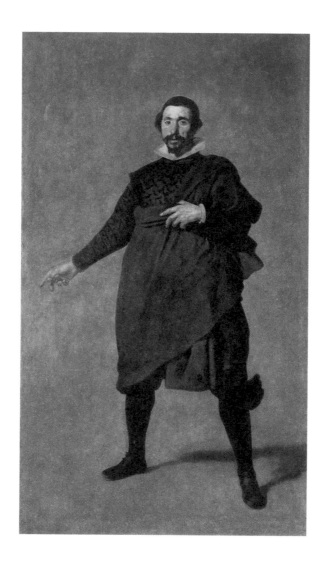

Diego Velázquez,
The Jester Pablo de Valladolid, c. 1635

three hundred and fifty years ago. But this is a painting, after all; it is oil on canvas, and certainly not photo-realism, so while I'm looking into his face, looking into his thoughts, his soul, at the same time I'm looking at a paint surface – and what a paint surface! It is another layer of enjoyment in this glorious painting.

And there, *The Jester Pablo de Valladolid* is standing with weight and in space. But where is the floor, where is the wall?

Velázquez has managed to paint space without any definition. That was just the aspect of the painting that influenced Manet, who stood in front of this very picture on 1 September 1865. He visited the Prado on that day, in company with a friend and patron, Théodore Duret. This painting was one of those, together with other pictures by Velázquez and Francisco Goya's *Third of May*, that made a particularly strong impact.

Manet wrote to a fellow painter, Henri Fantin-Latour, about *The Jester Pablo de Valladolid* when he was still in Madrid, insisting that Velázquez 'is the supreme master'. And, Manet added, 'the most extraordinary piece in this splendid œuvre and possibly the most extraordinary piece of painting that has ever been done is the picture described in the catalogue as a portrait of a famous actor of the time of Philip IV' – he means this one – 'The background disappears, there's nothing but air surrounding the fellow, who is all in black and appears alive.'

So, Manet, too, had a museum-age gaze, and learned a great deal – indeed, to an extent was formed – by the experience of visiting the Prado. Now, a century and a half later, we were seeing Velázquez, to some degree, through his eyes. His reaction, and the painting it led to, have become part of our gaze.

Goya: An Excursion

The next day we decided that before returning to the Prado we'd visit a much smaller place of pilgrimage for the lover of painting: the Real Ermita de San Antonio de la Florida or Royal Chapel of St Anthony of La Florida. This is a small, late 18th-century building on the eastern side of central Madrid. The point of visiting it, however, is not the architecture but the fact that the ceiling and dome were completely covered in frescoes by Goya over a six-month period in 1798. These make the interior of the chapel in effect a single work of art by the artist. In other words, it is what in contemporary art-jargon is called a site-specific installation. We stepped inside: above us was a visual world created by Goya.

PdM It's all of a piece; it's all digestible, close-by. He didn't have to deal with an enormous church or think about a great many themes, so there is tremendous cohesion, and the mark of the artist is manifest everywhere. It's architectural, yet on an intimate scale.

MG In the small central dome is a depiction of a miracle being performed by St Anthony of Padua. Around the base of the cupola, Goya painted an illusionistic railing with a wooden balustrade.

Francisco Goya, *The Miracle of St Anthony*,
Real Ermita de San Antonio de la Florida, 1798

Francisco Goya, *The Miracle of St Anthony* (detail),
Ermita de San Antonio de la Florida, 1798

PdM I like the unity of this; the canopy it forms. The *trompe-l'œil* is of a piece with the building, and in the tradition of so many such ceiling decorations, Goya makes you think the scenes in the frescoes are part of the architecture. The effect is all the more striking in that one is not looking up some two hundred feet in an enormous baroque church. And that variegated group of ordinary people looking down at us from the balcony in the dome is remarkable.

The saint and his miracle are almost details in the throng swirling around the base of the small dome. St Anthony is raising a man, a gaunt and naked figure, from the dead. All around them is a jostling crowd of people: beautiful young women like the *majas* in his other paintings, children clambering dangerously on the barrier, white-bearded elders. They are a cross-section of the pueblo: the people of Madrid as you would have encountered them outside here a little over two hundred years ago.

You feel the real subject is not the saint and the miracle, so much as the people watching it. Those 18th-century *madrileños* are an audience just like us, the modern spectators. In fact, there are far more of them, since this morning Philippe and I have the chapel to ourselves.

PdM The angels in the apse and spandrels around the dome don't look very holy. They are nice young women from Goya's entourage, almost like the dames d'honneur of Queen Maria Luisa. Or they could have emerged from a Parisian fashion walk and taken their places on the ceiling of Goya's apse. It's really quite marvellous to sit here in this chair and look from one group to another and then focus on just one, such as the three young female angels in colourful dresses over there in the apse.

MG They look to me as if they are on stage, dressed up as angels. Indeed, there is something consciously stagey about the whole thing. This is perhaps the last great religious fresco in Western art, and perhaps Goya was half aware of that.

PdM He painted these frescoes at the very end of the 18th century. The French Revolution had taken place, the modern world was being born. But for me, there was yet one more chapter in the history of grand architectural painting: Eugène Delacroix's murals for Saint Sulpice, in Paris, with the majestic depiction of Jacob and the Angel, and his glorious ceiling in the Galerie d'Apollon at the Louvre.

When Goya did these paintings, it was already intended that this building would house his tomb. In 1798, although he was only in his early fifties, he was stone deaf. He died in exile, in Bordeaux in 1828, but his body was brought back to Spain and buried in this church.

MG Goya here is even looser and freer in his technique than Tiepolo. The frescoes seem extremely fresh and vivid, as if they had been painted quite recently; but perhaps the paintings have been cleaned.

PdM True, I think there have been several campaigns of restorations. The frescoes were damaged by water at one point. Every work of art of some age that we look at has changed, and been restored. Sadly, the world's artistic heritage is no more immune than anything else to the inevitable deterioration of matter.

Rubens, Tiepolo, Goya Again

Back at the Prado we tackled another suite of galleries. The distinctive glory of that museum is the way you can see the work of five or six great painters in depth: Rubens, Titian, Velázquez, El Greco, Goya, Bosch. Having spent a good deal of time with Velázquez, and also Bosch and Titian, we now launched into the rooms devoted to Rubens.

PJM What you really have at the Prado is the taste of Philip II and Philip IV. We are looking mainly at the royal collections, which is one reason the Prado feels so cohesive. Among other things, these monarchs loved the pulchritude of Titian's and Rubens's women. The figures in *The Three Graces* are as earthy as any goddesses can allow themselves to be. They are all flesh and blood, dancing their paean to life in one of Rubens's sweeping landscapes, with deer grazing in the background.

I just love the opalescent flesh tones of these luxuriant nudes, the nacreous reflections on the skin, the way the thumb sinks into the flesh

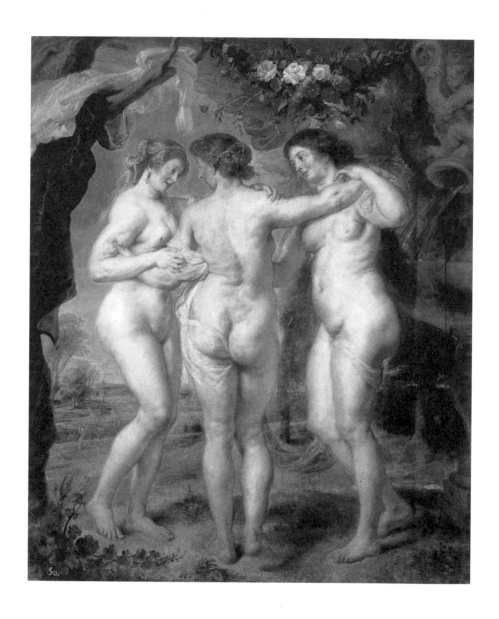

Peter Paul Rubens,
The Three Graces, 1630–35

of the Grace on the left; and their very charismatic, friendly expressions. Their generous forms are so naturally and sympathetically presented; all three, by the way, look like his two wives: Hélène Fourment and Isabella Brant. This is a hymn to female beauty, love and fertility – and to its brilliant and sensual transcription into paint.

MG Yes, you feel Rubens is telling us about what he, personally, loved. The composition is antique, but the three women are naturalistically, visibly, Flemish. However, the abundant fleshiness of their bodies is now a barrier to appreciating Rubens's art. He did not paint for an age that puts size-zero models on catwalks.

PdM They were beautiful to him. His women derive from classical sculpture, also from Titian, but most of all, from life.

MG Rubens treats sacred and profane, physical and spiritual, all with the same gusto and ebullience. Have you ever seen the altarpiece over Rubens's tomb in the Sint-Jacobskerk, in Antwerp? It is very touching in that way. It's a Madonna and Child with saints, but among the company is a voluptuous bare-breasted Magdalene, and a St Jerome like an old river god, and numerous chubby toddlers, full of life, just like his portrait of his infant son. You feel he's gathered his world, everything he cared for, in this picture.

And while he gained a great deal from looking at Titian and other predecessors, a great many very different painters who came after him developed a whole lifetime's work from a tiny corner of his world. Watteau, Van Dyck, Fragonard, Delacroix, Renoir – they all took a part and developed it. Rubens created a great banquet of painting out of which many painters carved a slice.

PdM If you look at the scene on the parapet in the middle ground of *The Garden of Love* in the next room, you can see exactly where Watteau came from. He was, one could argue, a Fleming too, by virtue of his birth in Valenciennes, part of the Low Countries until

the mid-17th century. In many ways, Watteau will redo this painting in a new mode, the *'fête galante'*, in the *Embarquement pour Cythère*. And all look back to the dreamy, poetic pastorals of Giorgione and to Titian's orgiastic *Bacchanal* here, just a few galleries away.

MG *The Garden of Love* is a feast of a picture, full of that very exuberant mannerist architecture that Rubens liked so much, and that very unsculptural sort of sculpture that you also get in Watteau.

PdM The sculpture on the fountain is no less alive than the figures in amorous embrace around her. *The Garden of Love* is a thoroughly satisfying work, grand even, if a bit diffuse as there's so much going on. It is a virtuoso *tour de force*, full of bravura but also of many subtleties: see how the red garment of the male figure on the right reflects on his lady's white dress. This gallery is filled with works by Rubens, a cornucopia of joyful, opulent and generous pictures that display his optimism and love of life.

MG Although his style is so familiar, and so much imitated over centuries, it is easy to overlook the fact that Rubens was an enormously original artist. Indeed, his work is wildly, sometimes weirdly, imaginative.

PdM True enough, and how Rubensian is Rubens, in fact, is clearly seen here at the Prado, as hanging together are Titian's *Adam and Eve* of 1550 and Rubens's copy of it, done in 1629, that respects the composition faithfully, almost. Let me quote the well-known observation of the French novelist Raymond Radiguet, which says it perfectly and tersely: 'A true artist is born of a unique voice and cannot copy, so he has only to copy to prove his originality.'

But you can be original and still derive inspiration from multiple sources, as is the case in Rubens's *Assumption of the Virgin* of c. 1637 in the Liechtenstein collection, Vienna. It is strongly influenced by Titian's *Assunta* of 1516 in the Frari Church in Venice, about which

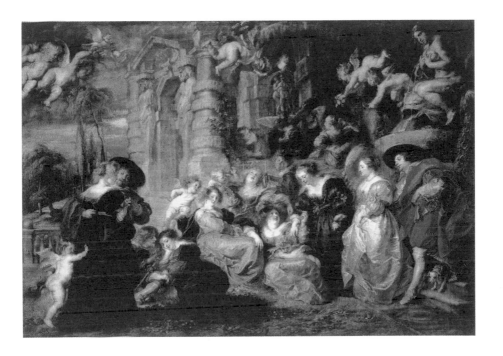

Peter Paul Rubens,
The Garden of Love, c. 1633

we have spoken elsewhere. As a curator, one might even be tempted to try to bring these works together for an exhibition. It would be a perfectly justifiable exercise. But issues of scale, weight and availability for loan would almost certainly rule out such a project.

For the Rubens is huge, about 17 by 12 feet, and cannot be rolled. Even for the Metropolitan, it was a huge job to bring it into the building for the 1985 exhibition of masterpieces from the Princes of Liechtenstein collection, then housed in their fairy-tale castle at Vaduz but now in Vienna.

Titian's *Assunta* in the Frari Church in Venice is bigger still, 22 by 12 feet, and on panel, therefore extremely heavy. It is unimaginable that the good friars would lend it, or that it would ever leave again after its traumatic displacements in the 19th and early 20th centuries. The *Assunta* is such an integral part of the church; painting and architecture there are one. The juxtaposition of these two great altarpieces is most likely to occur only on a PowerPoint presentation for the forseeable future.

MG There are comparisons that museums make very easy, such as the one between the two Titian *Entombments*. Others occur in once-in-a-lifetime temporary exhibitions, such as the juxtaposition between the London and Paris versions of Leonardo's *Virgin of the Rocks* that could be seen at the National Gallery for a few months in 2011–12. But still others are logistically impossible.

There was an exhibition of Giambattista Tiepolo in Venice and at the Met, which in its way was very fine. It did not, however, do full justice to Tiepolo because almost all his greatest works are immoveably attached to the plaster of walls and ceilings in Venice, Würzburg and here in Madrid. There are some exhibitions that can never happen, except in the virtual world of the Musée Imaginaire, on the pages of a book, or on a computer screen. You can't transport the ceiling of the Treppenhaus in the Würzburg Residenz on which Tiepolo painted his most amazing feat of aerial art.

PdM Oh, that grand staircase, that amazing illusionistic ceiling! Yes, or consider a Tintoretto exhibition after you've been in the Scuola di San Rocco, where walls and ceilings are covered from corner to corner and side to side with Tintoretto paintings, many so huge and powerful that San Rocco has been called Tintoretto's 'Sistine Ceiling'; Tintoretto envelops you totally and this experience clearly can't be replicated. Perhaps, for a new generation, amazingly elaborate three-dimensional HD digital devices can begin to suggest, not recreate, that sort of environment, or maybe some day multiple San Roccos will be projected in a theatre setting. I doubt, however, that technology can ever truly replace the experience of being surrounded and engulfed by the work of Tintoretto at the Scuola.

On our way to the galleries filled with paintings by Goya, we stopped in a room full of altarpieces and sketches by Giambattista Tiepolo and Giandomenico, his talented son and follower. Philippe paused at *Christ's Fall on the Way to Calvary* by the latter.

PdM In museums, when we can go from the 16th century to the 18th by simply walking through a door, as we have just done, it's hard not to help oneself making comparisons even if historically they may be meaningless. We've just seen Titian's *Christ on the Way to Calvary* of c. 1560, which elicits our response to the agony of Christ by concentrating on the episode itself, filling the canvas with only the figures of Christ and Simon, and like a third, equal protagonist, the huge and obviously very heavy cross. I would say that one of the major differences between this Tiepolo and the same subject as treated by Titian, is that Titian would have made sure that your response was to the stoicism and pain of Christ: he concentrated on the episode itself. Here with Tiepolo, the *mise-en-scène*, the staging, and the virtuosity of the painter are as important as the pathos. Giandomenico is more interested in the theatrical aspect of it. He invites us to focus on the turban, the brocades, and even the rich blue cloth upon which Christ has fallen.

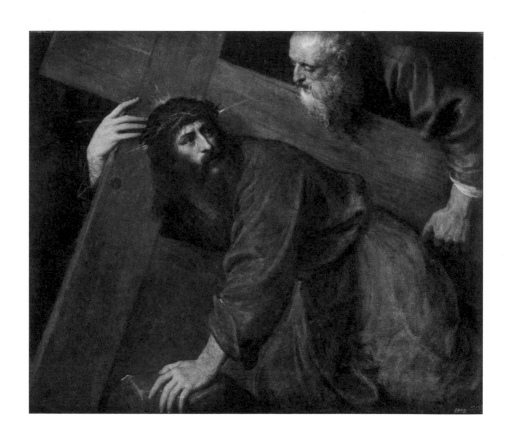

Titian,
Christ on the Way to Calvary, c. 1560

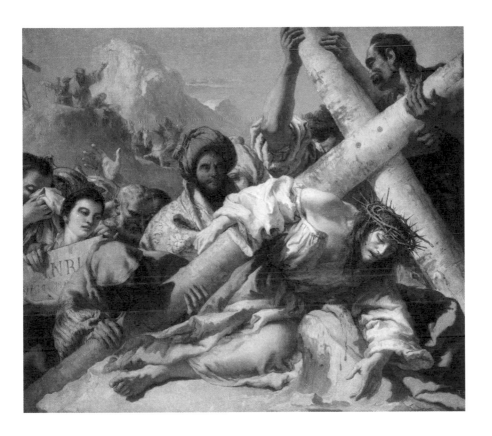

Giandomenico Tiepolo,
Christ's Fall on the Way to Calvary, 1772

At this point let me try to justify this arbitrary exercise by drawing some useful conclusion from it. I'll do so by looking at Caravaggio, as there have been a number of exhibitions recently of his and his followers' works. So, in pondering what accounted for the superiority and the lasting power of Caravaggio, I decided that a key factor is that great artists take a stand; they consider a subject and make a decision, have a *parti pris*, choose generally one over-riding facet of subject and manner, and concentrate on them with single-mindedness. That is one major difference between Caravaggio and the Caravaggisti (his followers), and it screams its rightness. There are many things to enjoy and ravish the eye in the works of Caravaggio's finest followers, but the image that will remain engraved in your memory, the picture that has shaken you, changed you, and that you will not forget, will be by Caravaggio.

You will be left with a general impression of the manner and personality of the best of the followers – and there are many whom I admire and enjoy on their own – but few of their works will be truly memorable.

I suppose another thing that these comparisons reveal is quite simply my own, maybe idiosyncratic, way of looking at art in museums. I do like to make relative judgments and compare – even apples with oranges – *mea culpa*.

MG Philippe, I don't think you should criticize yourself so much for making comparisons. The earlier one between Titian and Giandomenico Tiepolo illustrated exactly what we were talking about earlier in Goya's chapel: how, no matter what the pious beliefs of the artist or patron may have been, religious feeling seems to drain out of European art in the 18th and 19th centuries. And the second, between Caravaggio and his followers, makes the point that art is all about comparative judgments. We care about Caravaggio because his work was fantastically powerful. Gombrich once said to me that art history as a subject depends on evaluation: you can only define 'art' by distinguishing between good and less good.

We walked on to see the paintings by Goya. Like Velázquez, Goya is an artist whose work can only really be seen here. Admittedly, there are some masterpieces by the artist elsewhere, including one in the southern French town of Castres to which Lucian Freud once made a pilgrimage. Essentially, however, Goya's life's work is in Madrid, and mostly in the Prado. We paused for a moment in front of his celebrated, and almost sole, nude: *The Maja Desnuda* (*The Naked Maja*).

MG In comparison with Rubens, who was so much at ease with the naked body, Goya seems – though interested in the subject – much less practised at it. His woman's head does not belong to her body, and she has a very odd figure.

PdM Goya's model, too, seems a bit uncomfortable naked (or is she nude?). But Goya actually arrives at a more seductive result by being less anatomically accurate, through deliberate distortions – as did Jean-Auguste-Dominique Ingres, a great draughtsman, most effectively in his *Odalisque* in the Louvre, with its overly expansive hip and breast tucked under her armpit. If, among other things, Goya had been more anatomically correct in the rendition of her breasts, it would have made the woman less mysterious, and so less memorable. Also, so much else in the painting is ravishing, such as the cascade of white silk cushions and the delicate tones of the flesh, that Goya's liberties raise the picture to another level. And let's not forget the presence in the neighbouring painting of the same woman, in the same position, but clothed, Goya's *Maja Vestida*, which gives our looking at the 'desnuda' a voyeuristic quality.

MG It's true, her strangeness makes her more memorable, and although she does not fit together properly from the anatomical point of view, nonetheless she seems more real.

PdM The portrait of *The Countess of Chinchón* nearby, which it is simply impossible to disregard, reveals that simplicity and directness

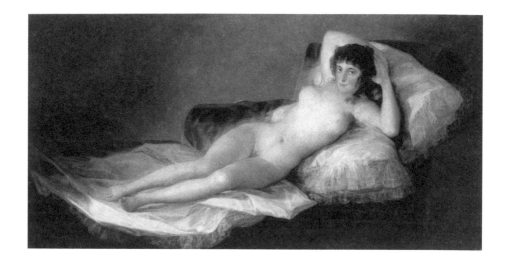

Francisco Goya,
The Naked Maja, 1797–1800

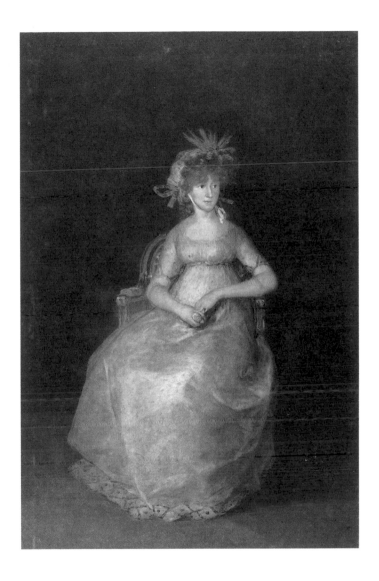

Francisco Goya,
The Countess of Chinchón, 1800

of approach in Goya that is so deceptive. The Condesa is just sitting on a chair in empty, undefined space and yet she has enormous presence; riveting and unforgettable with that head of wild hair flying out of the bonnet, which gives her a slightly crazed look. Goya has put down on his canvas all the information about the Condesa you could possibly need. This takes us back in a way to the point I just made about Caravaggio, the decision or focus of a great artist; here is a perfect example, where the spellbinding, even mesmerizing, quality of the picture is largely due to what Goya distilled from must have been there as the Condesa sat for him. Furniture, ornate walls and drapes were, for him, so many extraneous elements.

MG You can see exactly what he learnt from a Velázquez picture such as *Pablo de Valladolid*. Of course, as royal painter Goya was working surrounded by most of the earlier pictures in this museum, so he could look long and hard at Velázquez, just as Manet later looked hard at him *and* Velázquez.

PdM Incidentally, I first saw this picture when I had a cup of tea in the living room of the Condesa's heirs, most likely the very room where the portrait had hung for many generations.

MG Was there a difference in the way you experienced it there as opposed to here? Did it have greater impact in the sitting room than in this gallery?

PdM There is no comparison. While the family had other pictures, this was in the place of honour and captured all one's attention. Given the domestic setting, the picture also seemed bigger, more imposing, beckoning even more insistently. And of course, sitting in the living room, sipping tea, there was all the time in the world to absorb every nuance in the portrait and allow oneself guiltlessly to be seduced – and how seductive it is!

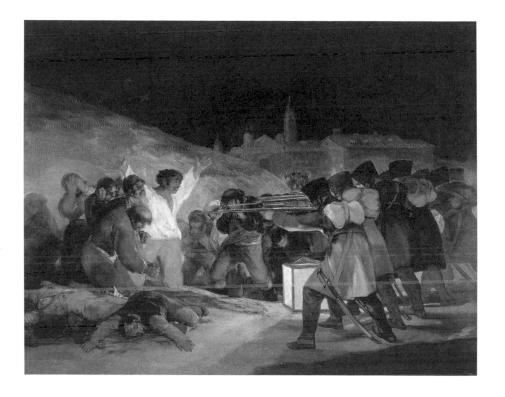

Francisco Goya,
The Third of May 1808, 1814

MG Manet felt that museums took the energy out of pictures of people. He said as much to the critic Antonin Proust, 'Museums have always driven me to despair. I'm deeply depressed when I go in and see how wretched the pictures look. There are visitors and attendants all milling around … The portraits just don't come alive.' All the same, he was hugely excited by his visit to the Prado.

Finally, we reached the room with Goya's two unforgettable images of political violence and death, *The Second* and *Third of May*. The latter particularly, seems to end one tradition – the religious contemplation of pious death – and begin another: secular images of atrocities in war and revolution.

PdM *The Third of May* certainly wasn't lost on Picasso when he painted *Guernica*.

MG It's a secular martyrdom, and much more powerful and deeply felt than any of Goya's explicitly religious pictures. Strangely, the feeling of spirited drama and mystery, which is very strong in Goya, only appears when he was not painting Bible stories, saints or altarpieces. Over here is Goya's conception of the still life as the entombment of Christ: *A Dead Turkey*.

PdM Indeed, with the turkey looking as if it's trying to raise itself up.

There was a pause while Philippe looked in silence at *The Third of May*.

PdM This is a picture that lives up fully to every possible expectation. It is among the most stirring and powerful of all works of art. There are no holds barred: the sea of blood, the terrified and yet defiant expressions of those about to be shot, and, as you pointed out, the secular martyrdom made explicit by the central figure's outstretched arms – the crucified Christ. As you've found out, Martin, there are pictures, many pictures, in front of which I simply don't wish to talk, but just be absorbed and absorb.

CHAPTER 17

Rotterdam: Museums and their Discontents

Our meetings in museums were both opportunistic and impulsive. That is, we saw what we could see and also what we felt like seeing. So, if we had been in the Netherlands a few months later than we were we would doubtless have gone to the Rijksmuseum in Amsterdam and stood in front of Rembrandt's *Night Watch*. As it was, when we were there the Rijksmuseum was still in the process of being extensively renovated. But Philippe had a strong urge to renew his contact with great Dutch painting, so we decided to drive south to Rotterdam to look at pictures in the Museum Boijmans van Beuningen.

The distance is not great and, leaving Amsterdam at breakfast time, we arrived half an hour before the gallery opened. While we were drinking a coffee near the docks, Philippe reflected on the way geography can affect the eyes, or, rather, where you are affects what you want to see.

PdM This morning, when we go into the building and look at a Ruysdael or Hals, are we seeing it differently, as I've asked in Florence, than if we were on Fifth Avenue in New York, or off Trafalgar Square

in London? Does a Dutch karma take hold of us that changes how we see things?

MG If you have a certain cast of mind, one that I have myself, then you particularly want to see Dutch paintings in the Netherlands, because they suit the spirit of the place. You would not be quite so open to them in the Uffizi. And, of course, the museum itself alters the terms on which we see things, and so, too, has the art book, the television documentary and now specialized websites. The order in which the works of art are hung on the walls affects the way one reacts to them.

PdM Indeed, and the curator has many different options. Before the 18th century, the arrangements were either along decorative lines (symmetry, similar size, etc.) or aesthetic (grouped according to colour, mood, etc.); then in the 18th century they become more didactic (chronological and by school) or thematic (by subject matter or function). The Kunsthistorisches in Vienna was one of the first museums to have its collection organized by an art historian. This was in the late 18th century. His name was Christian von Mechel, he took a leaf from the page of Luigi Lanzi, the art historian who had earlier installed the collections at the Uffizi chronologically and by school; he had also produced one of the first collections catalogues.

No sooner was the museum open, than we were through the doors and looking at paintings. In his book *Under the Volcano* the alcoholic novelist Malcolm Lowry observed that bars are beautiful in the early hours of day-light, when they are empty. For the addicted art lover, the same is often true of museums. They are at their most attractive when they have just opened, or are about to close, and are consequently calm and free of crowds. Except for a boisterous group of Dutch schoolchildren, we had the Boijmans more or less to ourselves.

We wandered around the galleries for a little while before Philippe stopped before a couple of canvases by the 17th-century Dutch painter

Pieter Jansz. Saenredam. There he paused for a long, long time, discoursing, enthusing and just looking.

PdM Ah, pure poetry! Do you know the Met doesn't own a painting by him? During all my thirty-one years as director I looked for a Saenredam but they were always either too expensive or they weren't good enough. I refused to have him represented by an ordinary or merely representative example. I wanted a great Saenredam.

Here there are two side by side: *The Mariaplaats with Mariakerk in Utrecht* and *The Interior of the St Janskerk at Utrecht*. I could spend a day simply looking at them. There's a whole world here not just of optical representation, but of the mind. In the exterior view there are no birds fluttering, and the presence of the dogs and the burghers becomes more an indication of scale to me than of life. I don't view this as a sociological study of 17th-century Holland. The only sense of transience and movement is in the sky; the figures are standing there chatting but not moving and even the dogs are at rest.

There isn't a boring square centimetre, even the fairly plain sky is interesting. You feel that this is a man who relishes the act, not only of rendering things seen, but also of the application of paint and the creation of richness in the most subtle range of harmonies, which makes it doubly rich. There's something very colourful about it, paradoxically.

The other picture, *The Interior of the St Janskerk at Utrecht*, might seem monochromatic. But it is not. It is about colour, about white as a colour. This is about the richness of white, the transitions between one shade of white and another, the *matière* of the paint. It's not topographical, although it's probably a very accurate depiction of the church. But, more than that, it's a depiction of emptiness; he's a painter of of silence, of space. I look at this and I think of the *White Flag* of Jasper Johns, where the attention is entirely on the surface, so that it's no longer a flag. The flag is the pretext for the painting. Here I go very quickly from realizing that I'm looking at the interior of a church to simply contemplating beautifully painted surfaces, so in a sense this is a very modern picture. It's a demonstration that

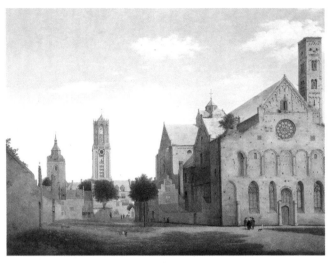

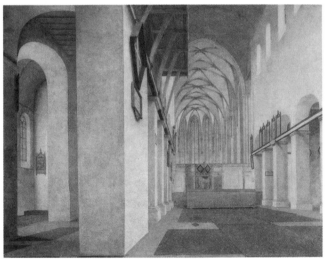

TOP Pieter Jansz. Saenredam,
The Mariaplaats with Mariakerk in Utrecht, 1662
ABOVE Pieter Jansz. Saenredam,
The Interior of the St Janskerk at Utrecht, c. 1650

there are a thousand different whites, as there are blacks. Looking at it, one understands Mondrian with his abstract geometric world of restricted colour; he was also Dutch.

I am actually physically drawn to the picture and need to stand about a foot and half from it. You know, there is a right and a wrong distance to view a picture, before it becomes a mere image, as in a book or on the Web. That's a key point. Most people stand too far from pictures, losing all sense of their physical presence, their quality of object, and by extension, the paint surface, the intervention of the artist beyond the creation of a composition.

The other thing is that I don't want to leave, to move on. I can imagine spending many more minutes in front of this Saenredam; then on to another. And then coming back to *The Mariaplaats with Mariakerk in Utrecht* and noting the reds and blues. Look at the variations in the ochres: how many different shades of ochre, salmon and *caca d'oie* are there on the side wall to the left? As I said before, although it is close to monochromatic, it is really about colour – and how a carefully chosen restricted palette range can be highly affective, yes, with an 'a'.

Do you see the donkey in the background with a leg up? He's about to take a step forward, yet he seems to be still, immobilized. Again, it's the clouds that are the only thing you feel will have changed ten minutes later. And perhaps the clock, but that you know intellectually; the movement of the clouds you sense visually.

MG So if it had been on the market while you were director, you would have bought this picture for the Met?

PdM Without any question, assuming I had, or could have, raised the necessary money.

MG I suspect Saenredam might well have used a camera obscura to observe the architecture. The paintings are from the 1650s and 1660s, about the time that Vermeer was painting pictures such as the

View of Delft, almost certainly viewing his subject through a lens. Furthermore, townscapes such as this one of the *Mariaplaats* were a genre in which use of the camera obscura became very common a few decades later, for example by the Venetian view painters.

PdM Indeed, but if you gave a hundred Dutch artists a camera obscura only one of them would paint Saenredams.

MG Agreed, just as many 20th-century painters used photographs as a source, but there is only one Francis Bacon and only one Gerhard Richter. It's a matter of taste, talent and sensibility. Saenredam is a good example of a great painter who isn't a great star with the public. The stars are relatively few, and you can detect their most stellar works by the almost constant knot of people who stand around them.

PdM There are so few of these stars and in the egoistical mood much art puts you in – no sharing – you might wish a painter like Saenredam would remain undiscovered by the mass public. On the other hand, if you put on an exhibition of Saenredam's work, some visitors might be smitten, and how can we begrudge that? An interesting issue, this; some of the great painters are not stars: Poussin, Watteau, Chardin, even Filippo Lippi, Vittore Carpaccio or Donatello, do not have the sex or box-office appeal of a Caravaggio, a Van Gogh, or a Picasso, which raises the question of how much what is known about an artist's life contributes to his stardom. And why, in the case of Caravaggio, he was neglected for such an extended period, and then only relatively recently propelled into fame.

Stardom raises yet another question, or issue, that needs addressing, which is that of the changing canon: a star today but not tomorrow. Look at the *Apollo Belvedere*, until the early 19th century it was revered as the most sublime expression of the human imagination, the work against which all others were measured. Then overnight, largely as a result of the appearance of the Elgin or Parthenon Marbles in London, it was discarded as stilted and effete.

After the Saenredams, nothing else among the marvellous Dutch painting collections at the Boijmans took Philippe's fancy quite so much. We paused here and there, enjoying Rembrandt — but Rembrandt is not a painter quite so much to Philippe's taste.

PdM He loved paint, loved the handling of it, you sense he was enjoying applying the paint and wants you to see that he takes pleasure in it. Velázquez, too, loved paint. He used it as would a magician to conjure up his figures, their convincing physical presence, as if from nowhere. As for Rembrandt — why stop here? — I find that sometimes he's too Rembrandtesque, that he paints *à la manière de* Rembrandt, drawing our attention to the thick paint layer, assuming, of course, that what we're looking at is an autograph Rembrandt in the first place.

MG I enjoy Rembrandt showing off his virtuosity with the brush. But we won't argue, because there is famously no arguing about such matters of taste.

No words were going to make Philippe feel the same way as I do about those lusciously thick gouts of paint out of which Rembrandt conjures up his son Titus. We stopped next at a painting by Hercules Seghers, *River Valley with a Group of Houses*, a great rarity, since there are even fewer surviving works by the eccentric and imaginative Seghers than there are by Vermeer.

PdM In a certain sense Seghers is the antithesis of Saenredam because his work is lush and rich and dramatic. While this is a topographical picture, there's a tremendous interest in the handling and transparency of the paint.

But in general I confess that over the last fifty years I have slowly lost interest in Dutch landscape painting. I get occasional revivals of my old thrills, but there are more and more pictures before which I have to work hard to get back my sense of emotive appreciation. I feel I have to work at it because I know that at one time in my life, I had the *coup de foudre*, and it is worth trying to recover that.

179

I use the word 'work' in my approach to art deliberately. This may seem odd to those who are accustomed to the populist message of museums that, eager to beef up their numbers by promoting their collections as a form of entertainment, go out of their way to suggest that the art within and the experience of everyday life are one. They don't want to intimidate the visitor with anything too grand, and above all, studiously avoid implying that there may be somewhere sensitivities higher than our own.

Imagine how much disappointment is thus engendered, as visitors find much of what is in the museum difficult; how much guilt is experienced by those who have been led to expect a thrilling experience simply by affording the work of art a casual glance. I'll grant you that getting across the message that art is difficult and requires attentive viewing and immersion is a hard sell, so to speak. Yet the museum must somehow convey, by the attitude of its staff, the mood, the tone set by the presentation, that a deeply rewarding experience awaits visitors if they are willing to look searchingly at the works on view. Also, that few works of art yield their secrets quickly and that, since most don't beckon, they must be approached and given time. There is a quote from Paul Valéry inscribed on the façade of the Palais de Chaillot: 'Il dépend de celui qui passe que je sois tombe ou trésor …' or, loosely translated, 'It depends on the visitor whether the work of art is to be a tomb or a treasure …'. We all know you can't squeeze Wagner's Ring Cycle into thirty minutes, yet, perhaps because the eye can take in a work of art all at once, in a brief instant, we expect it to speak to us in shorthand – it doesn't. It demands an effort; it must be deciphered, decoded if you will, if we are to be absorbed in its world.

Philippe did not find it, the *coup de foudre,* again in Rotterdam, perhaps because of the sheer quantity of rather similar pictures, which is often a barrier in collections of Dutch art. It was originally produced in great abundance, and in a number of distinct genres, such as still life, landscape, church interiors, flower pieces, genre scenes, to hang in private houses. In a museum, a few rooms of these can easily be too much.

PdM Looking at these three marines by Willem Van de Velde the Younger lined up on this wall, one can't help but feel that in a Dutch burgher's residence one would have enjoyed them more. In a museum you feel obliged to go in order from one to the other and this is not a neutral action. Something in the hang, as you say in Britain so conveniently, invites making comparative judgments.

That's both an advantage and a disadvantage of museums. These pictures were not painted to be seen side by side. It's not like Monet and Renoir sitting side by side at la Grenouillère in 1869 producing pictures that in every way it makes sense to look at together, nor certainly pendants, or a series such as Monet's *Poplars*. These Van de Veldes were painted separately, often at different times. But here, hung closely together, we are compelled to look at them as sequences. When was the last time you saw a picture by itself, by the way? Of course, I am not suggesting that pictures were once displayed in isolation; works of art have always, in one way or another, been placed in conversation with each other: just look at the installation in Roman palazzi, whether Colonna or Doria Pamphilj, to see pictures hung cheek by jowl, in an overall decorative scheme. In the general randomness of such installations, because there was often no more of a rationale for placement than size, colour and scale, no studied narrative emerges or imposes itself – which is not necessarily bad, by the way.

Today we look at pictures differently and seek their singularity, not out of the random multiplicity in the presentation, but out of an art historically dictated progression, one which, as I mentioned, started to be applied in the late 18th century.

We strolled on into a gallery that contained early Flemish paintings, including among them one version of Pieter Bruegel's *Tower of Babel*, another example being in the Kunsthistorisches Museum, Vienna. It is a small painting, about 24 by 30 inches, but contains a world. An enormous, unfinished multi-storeyed structure rears up, a fantastic enlargement of the Colosseum of Rome (which Bruegel had seen on a visit to Italy a decade previously). On the spiral ramp that winds around it are minute workmen, scaffolding,

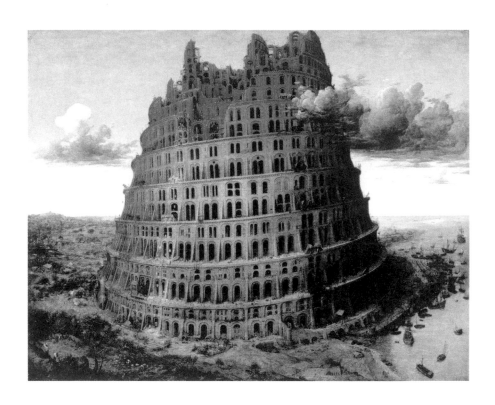

Pieter Bruegel the Elder,
The Tower of Babel, c. 1565

cranes, piles of mortar and masonry. Clouds form around its top, below there is a harbour with ships coming and going, and on the other side a rich countryside with farms, trees and fields stretching away until it meets the sea near the horizon.

PdM As with the Saenredam, I'm enjoying the fact that I'm looking into the distance behind the Tower – how many miles? I love space.

MG This picture is like a feat of magic: so much is compressed into so small an area, which when you peer into it expands in your mind. You suspect it might have been painted with the use of a lens, not to project the image, but to magnify the surface. Certainly, you almost need a magnifying glass to enjoy this picture. It's necessary to get very close.

PdM As you get very near to it, the picture is magnified, inviting very close scrutiny; and what a rich Lilliputian world is revealed. Of course, this being a 16th-century Flemish picture, you know that this is about more than mere anecdotal incident …

MG A large painting can be quite simple, if intended to be seen from a distance. Think of a Rothko or a Barnett Newman. But this is a macrocosm packed into a picture less than three feet across. You are intended to spend a long, long time with it. A lot of it is on the scale of a miniature, beyond that in some ways, with figures no more than tiny dots. The bits of building equipment on the upper storey are like spiders' webs, but it's also a strong legible image. You can see the tower from the other side of the room …

PdM … with two little birds anchoring the landscape.

Star-Spotting
at the Mauritshuis

Before we left the Boijmans museum, we looked at every single room, but
– perhaps because the Bruegel put us in a mood for miniatures – the other
painting we lingered over was also small, smaller indeed than *The Tower
of Babel*. It was a tiny Virgin and Child by the 15th-century Netherlandish
painter Geertgen tot Sint Jans.

It was painted on a panel eight and a bit inches by ten and a half, or a
little more than the screen of an iPad. According to the label, it was once
the right half of a diptych, of which the left side (showing the Crucifixion) is
in Edinburgh. It is a painting of something that was always hard to imagine,
and especially to visualize: the highest circles of Heaven, as described by
Dante in the Paradiso. It is an image of a dark sky filled with immaterial
beings – angels – who are diaphanous, and are making sound. In the middle
are the Virgin and Child, radiating light.

PdM She's enthroned on a crescent moon, which itself has a lizard or a
dragon creeping from underneath it, probably symbolizing sin being
overcome. Amazing things are going on, here an angel is blowing on

Geertgen tot Sint Jans,
The Glorification of the Virgin, 1490–95

a trumpet and there another one something that looks like a bassoon. They are all playing musical instruments.

This is a private devotional picture to be prayed to or at least in front of. Although over time – many, many times – you would do your devotions, with prayer as the primary vector to the picture, little by little you would be bound to have discovered everything depicted in it. Because the artist is so skilled and endowed with such a poetic nature, I can't but believe that even the most devout would not have had, even if unconsciously, an aesthetic response. And there lies one of the characteristics of great art, which is that it must 'work', that formal artistic conception and purpose must so perfectly translate, as in this case, the votive purpose, that icon and art are inextricably fused. In other words, because the votive image succeeds as art, it then moves deeply as a religious experience. Put yet another way, a pedestrian, inept, prosaic rendering of a deity is unlikely to move the onlooker to piety.

MG So it was originally intended to be an extremely private image, not for a public place such as a church, but for its owner to look at every day, and use to focus his or her devotions. Here is an example of the kind of artist about whom we know almost nothing; the first biography was not written until 1604, at least a century after his death, and it tells us little more than that he lived in Haarlem. He is just a name – meaning, approximately, little Gerald of the Knights of St John. He is only a step from anonymity, but a distinct sensibility emerges from his surviving paintings, though they number less than a dozen.

PdM That's true, and perhaps for this reason I have always sought out his work. There is something about the pronouncedly oval faces and curiously hard, rigid countenances, that is reminiscent of polychrome sculpture; there is also a naive quality in this doll-like child kicking his legs so naturally, while at the same time, this otherworldly apparition emerges dramatically from an incandescent light peopled by

the music-playing angels, evanescent, ghostlike. So much charm here, such honest painting!

We broke for lunch — a hearty Dutch meal of cheese pancakes and beer, eaten in the market square at Delft — then drove on a few miles further north into the centre of The Hague. One of the richest small art galleries in the world is there, in a delightful little 17th-century building on a lake in the centre of the city: the Mauritshuis, which contains the Dutch Royal Cabinet of Paintings.

Philippe, however, bridled before we even entered the museum, as huge banners on the façade carried images of one of the most celebrated paintings in the world: *Girl with a Pearl Earring* by Johannes Vermeer. His mood hardly improved as we stepped into the entrance hall to buy our tickets. There we were confronted once again with huge colour posters of the museum's most famous possession, and in the last three decades the subject of two novels, a feature film and a play.

PdM Now, I don't even want to see the actual painting; they've ruined it for me. I've seen her image ten times before and after entering the museum. It's really a travesty to do that. They should take every one of the posters down! It's one thing to have them in Chicago and Berlin where the picture is not, but to have giant images in the entrance to the Mauritshuis assailing the eye in this way is inexcusable! Why would you want to diminish the work like this, to reduce the impact? It kills the freshness of the experience, the element of surprise, of discovery. I figure my reaction to the painting would be to say, 'Oh, there she is', and I'd hardly afford her a second glance.

So, instead, we climbed the stairs of this building, which is constructed in a style that to British eyes recalls the work of Sir Christopher Wren, who was influenced by this kind of Dutch architecture. The rooms are small in scale, as they were in one of the two types of space favoured for looking at art in the 16th and 17th centuries: the cabinet. This was an intimate location for displaying and appreciating smaller items (though the paintings were

Bartholomäus Bruyn the Elder,
Portrait of Elisabeth Bellinghausen, c. 1538–39

hung floor to ceiling rather than spaced out in a row as they are now at the Mauritshuis).

Once more, Philippe's attention was grabbed by a tiny work, even though it was anything but prominent, lying flat in a display case, by a little-known artist, indeed even less of a household name than Saenredam or Geertgen tot Sint Jans: Bartholomäus Bruyn the Elder. His little *Portrait of Elisabeth Bellinghausen* totally bewitched Philippe.

PdM This is sensational. Look at the deep-set eyes, the endlessly high forehead, perky mouth ... oddly, she's like a waxen figure; it's not flesh, she's not real, as if this were an alabaster Egyptian bust. I want to take her home and live with her, not sleep with her, just look at her. In its own way, this is as fine a picture as *Girl with a Pearl Earring*. I exaggerate, of course, because I'm still irked by the Vermeer non-experience, but today I am definitely going to spend more time with her than with the Vermeer, because she's not plastered on posters. The Bruyn should also be much better known, but her stardom has been eclipsed by her proximity to Vermeer's undisputed masterpiece.

It's an interesting question whether she is really as compelling as the *Girl with a Pearl Earring*. It is almost impossible to say, because the latter is so familiar that it is hard to assess objectively. What is undoubtedly true is that two hundred years ago, the name of Johannes Vermeer was as unfamiliar to art lovers as that of Bartholomäus Bruyn is today. The rise of Vermeer's reputation in the 19th century is a perfect example of the unpredictable nature of art historical fame.

Vermeer was an artist of repute during his lifetime, but was almost forgotten for over a century after his death. His fame rose during the 19th century, so that by the end of it he was firmly established in the position in which he remains today: as one of the most extraordinary and mysterious, almost magical, painters who has ever lived.

Nonetheless, when we went into the room where the Mauritshuis's two Vermeers – *Girl with a Pearl Earring* and the *View of Delft* – both hang, Philippe first looked at a couple of pictures by Saenredam. Only then did he

switch attention to the painting in the middle, which did, after all, live up to its reputation:

PdM When people first saw the *View of Delft*, it must have seemed that it was not done by a human being – it is such a miraculous, palpable rendition of sky, city, water; of light, of space. And it's a supremely intelligent picture.

This work was the subject of one of the most celebrated gallery experiences in literature. In 1921, it was included in a mammoth exhibition of Dutch art at the Jeu de Paume in Paris. The novelist Marcel Proust, who had seen it twenty years before, was determined to look at it again. So at 9.15 a.m. on 24 May, instead of going to bed as he usually did in the morning, Proust went to the exhibition in company with an art-critic friend.

Far from well, feeling giddy and weak – he died less than eighteen months later in November 1922 – Proust stood in front of the picture. His experience that day was the basis for an episode towards the end of his great novel, *A la recherche du temps perdu,* in which the critic Bergotte, also experiencing dizziness, actually dies in front of the picture. His last gaze is fixed on a 'little patch of yellow wall with a sloping roof', which seems to him to possess the self-sufficient beauty of a masterpiece of Chinese art. That, Bergotte feels, is how he ought to have written. He expires, repeating the phrase, 'petit pan de mur jaune'.

PdM This must be the patch of yellow here, catching the sunlight, with the water gate in front in shadow, referred to in that beautiful passage by Proust. We're at the right distance from it now, just where you get those little flickers of light that you don't see from further away, and in your imagination you can actually move your little boat slowly underneath the bridge onto those still waters. The women in the front look as if they are wearing whipped cream.

But a problem with a picture as popular as this and so very rich and complex and inexhaustibly captivating, is that you feel guilty if you linger as you wish to and as you must, guilty that you are in the

Johannes Vermeer,
View of Delft, c. 1660–61

way of someone else wanting to look at it, so you move on, frustrated. It's not really possible any more to have Proust's experience – or Bergotte's – (which is actually the so-called Stendhal syndrome) in front of this painting, it's just too well known, too sought after: who has the time to swoon, let alone die?

Where Do You Put It?

PdM Art history reflects the Western compulsion for categorization, for wanting to set things apart, classify them, put them in some sort of order, and then study them and interpret them.

We were having lunch on the Quai Voltaire, in a restaurant commanding a panoramic view of the Louvre, as good a place as any to discuss – over asparagus and mayonnaise – that fundamental question facing every museum and collector: how do you order the various things you own?

PdM Even in my own apartment, with the little I own, I have somehow organized the objects, some at least – those not on side tables or on the mantelpiece. So, Chinese archaic bronzes and Han pottery are on one shelf, Islamic art on another, and ancient Greek and Egyptian baubles on yet another. As for Old Master drawings, another area where I collected a bit, they hang on the walls. Now, however, our children are grown, our flat is smaller, and I've given most of the good things to the Met.

MG You used the term baubles; do you mean that these are not art?

PdM No, they are simply minor pieces of the sort museums call 'study collection material'. What defines art is something else. Take this shallow, flat glass container on the table. The restaurant placed it there as a receptacle for cigarette ashes. It is an ashtray. If I were to put it in a vitrine in a museum's decorative arts gallery, it would no longer be an ashtray, a functional object, but one with no further use except representing good design. You could make that point about a great many things that now inhabit the art museum, and not just manifestly utilitarian objects, such as a sword in an arms and armour gallery, converted from a very serviceable and deadly weapon into an aesthetic piece of beautifully shaped and handsomely crafted metalwork.

This change of context/change of meaning phenomenon was exploited playfully/seriously in an African art exhibition in the 1980s, entitled 'Art/Artefact', where a tightly wound fishing net from the Zante in Zaire was installed alongside African masks in a separate vitrine. The point being that most visitors following well-engrained expectations in a museum setting would not question its presence in this context, and would look at it as art.

Also, the fishing net was beautiful, and the curator was drawing attention to that, while simultaneously pointing out that it was not a work of art. And in fact, collections of art of all kinds are full of objects that have been, at some stage or another, reclassified. Most of the objects in museums were never intended to be there, and many of them were made by people who had never heard the word art either. In that respect, private and public collections are much the same: they are full of stuff originally intended for some other purpose altogether. Ashtrays are made to stub out cigarettes in, not to be admired as pieces of decorative art.

A private collection need have no other common factor than that the objects be in accord with the taste or whim of the owner. In my own case, the things that could be called a 'collection' are no more than the sum of objects that my wife and I have happened to accumulate and liked enough to keep.

MG Lucian Freud once said to me that 'in the end nothing goes with anything, it's your own taste that puts things together'. I think that's true: there is no preordained way to classify the multiplicity of objects that might be collected. One strategy, of course, is to pile up items of one type – row after row of fans, or antique clocks. Alternatively, the collection might focus on a time and/or place: 14th-century Italian painting, 19th-century Japanese artefacts.

Yet another type of collection can be put together out of materials that – considered geographically or chronologically – might not seem to have anything in common at all. The Surrealist poet André Breton, for example, amassed heterogeneous objects including tribal art from Oceania and the Pacific Northwest of the North American continent – plus a multitude of pieces by his friends and contemporaries, such as Marcel Duchamp and Max Ernst. What bound all this together, clearly, was Breton's mind and sensibility.

Not long ago, Damien Hirst said: 'Collecting is like stuff washed up on a beach somewhere, and that somewhere is you. Then when you die, it all gets washed away again.' A collection is, then, an expression of a personal vision: in a way, a work of art in itself. But collecting is also – both for individuals and institutions – a compulsion.

Howard Hodgkin, a distinguished living painter who has built up a celebrated array of Indian paintings, is frank about this. 'It is true up to a point that it's a creative act joining together disparate things. A great collection certainly has a character of its own. But it is accumulation. That can happen to anyone if they are unlucky enough to catch the disease.' Collecting, Hodgkin insists, is a form of shopping. But it also takes on its own life. Once the 'design' of the collection has formed in the collector's mind, according to Hodgkin, then things have to be bought out of 'necessity as well as passion'. That, he believes, is the most dangerous, but also the most creative, phase of collecting, involving the head as well as the heart and other 'lower organs'.

The 'design' of the collection can be defined in an infinite number of ways, and once it has been pinpointed the collector – or, at least, one type of collector – will want to accumulate a large number of items falling within

that definition, of the highest possible quality. Alternatively, a collector might want to corral the widest range of objects within that category, thus demonstrating, say, how diverse snuff boxes can be.

In other words, collecting is – among other things – a sophisticated variety of labelling, or what scientists call 'taxonomy'. Of course, putting labels on things is one of the staple activities of museums. Indeed, museums are, viewed in one way, elaborate labelling institutions. Large ones, such as the Met, have many departments, administered by expert curators who function rather like public versions of private collectors. They try to accumulate the best examples and the widest range of whatever it is they are responsible for, be it musical instruments or Old Master paintings, and once they have got them, they aim to look after them and display them to best advantage.

However, the things in the world can be classified in an indefinitely large number of ways, and we – meaning the collective consensus of people who buy, sell, care and write about such things – are constantly changing our minds about what is particularly beautiful and important. The result is that there are always things that are hard to label, awkward things that do not fit into the normal pigeonholes.

PdM In museums, taxonomies do not have the elasticity to allow easily for change. And it's not always an intellectual limitation, it's an administrative, physical and architectural one.

I was at an art fair recently where I saw some impressive stone markers, clearly from a cemetery. I'd never seen anything like these. It turned out that they came from Indonesia – the former Sultanate of Aceh – dating from the 17th or 18th century, and displayed a mixture of local tribal and Islamic designs.

I think they have tremendous power and are true works of art of indigenous creation. But if I were still Director of the Met and wanted them acquired, I would ask myself, 'What curator would I approach, what department would they belong to?' Would I go to the Byzantine curator? I'm not so sure they are Christian. Would I go to the curator of Islamic art who might argue that they do not fit into the framework of the mosque or courtly arts shown in the galleries,

Tomb stele, 17th–18th century, Indonesia

Double diptych icon pendant,
early 18th century, Ethiopia

only now beginning to embrace new and more popular categories. Would I go to the curators of African, Oceanic and American tribal arts? What do you do with them? Since even large museums cannot have staff to cover the whole gamut of human creation, many works of art fall in the cracks and tend not to be actively collected, or they are displayed in distinctly liminal spaces – such is the case at the Met for European migration material or nomadic art of the Eurasian Steppe, or even much of Central Asia.

MG Sometimes the museum finds a space for a novel variety of object and in doing so slightly reorders its classification of the world's art. The question, 'Where do you put it?' involves much deeper questions: what is truly significant among all the bits and pieces *Homo sapiens* have made up to date? What is the most crucial part of the history of human culture? Is it the work with distinctive stylistic identity, often emanating from imperial centres – the Rome of the Caesars, Tang China, Ancient Egypt? Or is there perhaps equal interest in items from the transitional areas in between, where one culture filters into another?

PdM Well, take a look at this image on my mobile phone. It is a small diptych from Ethiopia, on the periphery of the Byzantine world, from around 1700. It's a work of the sort that until quite recently would have been considered tangential, naive and not worthy of a serious museum. This diptych was brought to me, some fifteen years ago as a proposed purchase. I said, 'Very nice, but where does it fit in the collection? And surely this is not high art?' I had difficulty in reconciling myself to it.

I must have sounded like the 19th-century Assyriologist Henry Rawlinson (he was key in deciphering cuneiform script) reacting to the Assyrian lamassus (winged bulls) and lion hunts sent back to London from Mesopotamia by the archaeologist Austen Henry Layard. These, Rawlinson refused to see as art. For him, the canon was the Elgin Marbles.

For me, I guess, with regard to the Ethiopian diptych, the canon was art of the imperial Byzantine court. However, the curators persisted, passionately, and persuaded me that the diptych should be approached on its own terms as it represented an important offshoot of Byzantium in outlying areas, which displayed their own individual and distinctive native styles. I supported the purchase, and we bought the diptych. We were later to purchase many more objects from Ethiopia, addressing another issue I had with it, which was that alone, the diptych made little sense as it didn't fit comfortably anywhere. But once a critical mass of objects was acquired, they formed a cohesive group that told us much about parts of the world heretofore neglected in a history of art heavily weighted towards courtly traditions.

One has to recognize that on their own merits the Ethiopian pieces are best of kind. However, it does raise the question: where does that 'kind' fit in the hierarchies? Perhaps the hierarchies my generation was brought up on are to be discarded, are being discarded, in favour of a more inclusive, pluralist approach. Truth be told, I have learned to look at such works with as fresh an eye as possible, and to see how they might appeal to modern sensibilities, perhaps more even than imperial art from Constantinople. As to where they are shown, now that several are in the collection, an interesting dialectic has been applied, with some displayed in the Byzantine galleries, and others with African art.

So this image, for the time being at least, has a dual identity – part Byzantine, part African. But it is worth revealing that neither of those categories would have meant anything to the connoisseurs and thinkers of the 18th century who did so much to form our modern Western notion of a museum. 'Byzantine' is more or less equivalent to the era that the historian Edward Gibbon chronicled as the *Decline and Fall of the Roman Empire*.

To those with an ingrained admiration for the achievements of classical Greece and Rome, the creations of Christian Constantinople and its zone of influence just looked like decadence. This was not something to admire, but simply a negative: a sad falling away from everything to be valued and

imitated. The taste for Byzantine art did not appear until the late 19th century, and Byzantine departments are still a novelty in several great museums. While 'African Art' – now a prominent department in such huge institutions as the Met and British Museum – would have sounded like a contradiction in terms in the age of Gibbon. For centuries, progressively, the quantity of objects in the 'to be admired and valued' group has steadily expanded.

The starting point of the process was precisely in the classical world of Greece and Rome. The scholars of ancient Alexandria defined a 'canon' of works of literature that were considered, as we put it today, classics. Similarly, the rulers of the kingdom of Pergamum on what is now the Aegean coast of Turkey, put together something resembling the ancestor of a modern museum. In their palace and the library in the sanctuary of the temple of Athena, they brought together an array of paintings and sculptures – both original masterpieces and copies – that illustrated the development of Greek art. This in turn was an evolution from the temple treasury, such as those at Delphi, to which statues, paintings and other works of art were presented for religious reasons. These eventually became attractions admired by ancient Greek and Roman tourists.

Scholars attached to the library at Pergamum such as Antigonos of Carystus (3rd century BC) wrote studies of individual artists that were bound together in a long-vanished volume called the Canon of Pergamum. When the Romans took over the realm in 138 BC, they also imported this set of judgments about who and what was significant in the history of art. It constituted the handbook of taste for Roman collectors, and underpinned the writings on art of Pliny the Elder.

In the 15th and 16th centuries, Italian connoisseurs took Pliny's views as unimpeachable wisdom, taking note of his descriptions of works long disappeared, and greatly revering the *Laocöon* – the one piece included in this canonical list that could actually be seen after, to great excitement, it was dug out of a Roman vineyard in 1506. More modern artists such as Raphael and Michelangelo were fitted into this roster. And the process continued in Europe after the Renaissance, so that by the mid-19th and 20th centuries, the canon had come to include works by all manner of cultures – Assyrian, Chinese, Japanese, Maya – completely unknown to Renaissance Italians or

Khatchkar (Stone Cross),
12th century, Armenia

the inhabitants of ancient Pergamum. This process still continues, and as it does more and more objects get moved, figuratively speaking, inside the temple sanctuary.

PdM There are in Armenia beautifully carved tombstones called khatchkars. They are being systematically destroyed in the Armenian part of Azerbaijan in some kind of ideological war. There is now a khatchkar on display in the Met. In our effort to help conserve at least some of these impressive stone markers, we were in fact assigning a place for them in the history of Christian art. It's not exactly Byzantine, I guess, because the Armenian Church is independent, but closer to Byzantium than to the Western Church.

Thanks to the special loan to the Met, this carved stone has entered the latter-day equivalent of the Sanctuary of Athena at Pergamum: it is preserved, protected and at least a candidate for a place in the canon. It is no accident that so many museums boast porticoes derived from ancient temples – the British Museum, Altes Museum in Berlin, and Met, to name just a few.

The museums of the modern world are filled with treasures – that is, objects we value – just as the temples of the ancient world were. Furthermore, museums and private collections of art alike abound in things that were once to be found in temples, mosques, churches and similar sacred structures.

Exploring the Rainforests of Paris

In Paris one morning we decided to go to the Musée Guimet, or – to give it its full title – the Musée national des arts asiatiques-Guimet, which is situated to the west of the city centre on place d'Iéna in the 16th arrondissement.

It is a monument to Gallic contemplation of Eastern civilization. The exterior is opulently classical – which in Paris is one of the main modes of museum architecture. We walked inside, bought a ticket and went into its calm, orderly galleries.

PdM This is a museum that began its life with Monsieur Guimet, who was an avid collector, but not of art per se; rather, his aim was to use the collection to trace a history of Eastern religions.

Emile Etienne Guimet sounds like a characteristically 19th-century figure. He was a busy industrialist, but he also found time to travel extensively, to Egypt in 1865, and around the world in 1876–77, taking in the USA, Japan, China and India. Above all, he was interested in the movements of deities through time and space, such as the colonization of the Egyptian goddess

Isis by the ancient Roman religious sensibility. He began to build a museum in Lyon to hold the material he had gathered, but changed his mind and decided to present it to the French state.

PdM Unlike most major American museums (not the specialized ones, of course), the Louvre, though born of the Encyclopédie, is not truly encyclopaedic.

It is a museum built along the lines set during the age of Enlightenment, when the history of art traced the 'progress' of Mediterranean/European cultures, proceeding from Greece and Rome to the then-modern era, represented by the neoclassicism of Jacques-Louis David and his contemporaries. The story was missing key chapters because those in charge followed the prevailing canon, so medieval art, for example, was not included; it was rehabilitated a bit later, benefiting from the Romantic view of the world. As for East Asian art, it enters the Louvre in bits and pieces, distinctly peripheral to the main narrative, and is transferred to the Guimet when that collection becomes a public museum at Guimet's death. This is not a criticism, by the way, as East Asian art was never in the minds of the founders of the Louvre. And so, in Paris, Asian art (South Asian Islamic aside) ended up in the Musée Guimet.

The Guimet, in addition to housing its founder's own collections, re-groups many others that were either purchased or given. Significantly, it also presents a good deal of excavated material, notably from Afghanistan, and, of course, there are many colonial appropriations from Cambodia.

The Khmer hall where we are standing, for example, houses the greatest collection of Khmer and pre-Khmer art outside of Cambodia, just as in Leiden you find a superlative collection of Indonesian art, because Indonesia was a Dutch colony. So, yes, in many a European museum you have the trophies of colonization. Here, in fact, as they are displayed, the works have the telltale signs of trophies of conquest. Look at the statues, just about every foot is cut off. These figures were literally hacked away from many of the

temples in Angkor and the surrounding area throughout the late 19th and early 20th centuries.

The colonial rapine of Cambodia yielded this great collection; but paradoxically, it is as a result of this that the civilization was first seriously studied. In our day, when we relish wallowing in retrospective guilt, we need to remember that there was a repayment in scholarship and knowledge. Even the countries of origin were ignorant of, or at least indifferent to, what is today claimed so fervently as prized patrimony and – according to the restitution claims – national 'property'.

In a debate that is most often short on objectivity, a key question would be to ask if civilizations decay, or simply disappear after a catastrophic event, as is supposed to be the case with Angkor. Why did the Khmers care so little, or forget so quickly, such huge monuments that took so many people, so much skill and so much time to build? Did the civilization that created Angkor belong to the people or just the ruler and the priests or officials? What was it that made the French care so much more about Cambodian 'heritage' than the locals themselves, at least initially? By what standard or value are the temples and images judged by Westerners and by locals? Are the present Cambodian scholars and curators simply carrying on the work of the Western scholars, or have they developed their own value system and approach to the study of Hindu–Buddhist images and monuments, which are considered in relation to their own history?

If Hindu gods are no longer important to Cambodians, why should they preserve them except as 'national patrimony' and 'works of art' – both ideas introduced from the West? I am not an expert in this field, but I know enough, I think, to suggest that such questions should be asked.

At the base of the stairs is a naga balustrade from the temple of Preah Khan at Angkor. It dates from the 12th century and is a simply astonishing sight. Seven heads rear up from the thick body of a gigantic serpent, each one crested and plumed, and the entire creature rises far higher than

Naga balustrade from the temple of
Preah Khan, Angkor, Cambodia, late 12th–early 13th century

the height of a human being. It is held, apparently reverently, by a group of attendants.

PdM This extraordinary work has been in France since the 1870s; it was part of the first excavations when the temples were recovered from the jungle that had all but swallowed them. Large as this stone sculpture may be, it was easily transported to Paris. Decades later, once the temple complex was largely cleared of the invading vines, it became painfully clear how the loss of this phenomenal object's context within the temple leaves an almost ecological void.

Of course, with smuggled objects, the question of accountability is complex. This applies to most of the 'source countries', not just Cambodia, where people in official positions had a hand in the operations; the 'crime' has been committed before the objects leave the country. Does this excuse anybody else? No, but only if we continue to confuse and conflate legal, ethical, moral, cultural and historical issues.

Also, in a different vein, I have often wondered how differently we and the local inhabitants view the ancient heritage when it is, on the one hand, as in Greece and Rome, not only above ground but part of the urban fabric, and also in texts; and on the other, when the monuments are, for the most part, buried or out of sight, and either unknown or largely forgotten.

MG The nature of that rediscovery, of course, has been debated. It is disputed by some that the temples of Angkor were truly that neglected and overgrown. It is often thought that the wholesale removal of works of art by colonial powers was theft, plain and simple. I remember once going to the British Museum with a group of Japanese visitors. One of them more thoughtfully observed that Britain must have been a most powerful country to have taken all these things from other places.

Obviously, that observation was undeniable. The transportation of the Benin bronzes from Nigeria to Bloomsbury was as much an

expression of British power as the extraction of large chunks of sculpture from Cambodia to Paris was of French colonialism.

However, these Khmer sculptures in front of us, like this 10th-century Brahma in the Kho Ker style, really are cut off, not only from their architectural setting, but also from the interwoven meanings they had for the society that made them. At the Musée Guimet they are shown in a cool, minimalist installation, each on a separate plinth, spaced out for individual aesthetic contemplation. The effect is beautiful, but far from the florid profusion of a Khmer temple. They could be so many Giacomettis.

PdM First let me say that the interwoven meanings you refer to are a thing of the distant past; the Khmer temples and their deities have long since ceased to play a part in the lives of those who live in Cambodia today ... on the other hand, you're right, putting the object in a sort of white cube emphasizes the break from its original context. In its so-called neutrality – with those pedestals of carefully selected stone, with these very light coloured walls – in its great refinement, paradoxically, the installation actually provides a new context in which the presentation as aesthetic artefact draws attention to itself in anything but a neutral way.

When we planned our own Khmer court at the Met, we were influenced by the Guimet. There's no question that museums look at each other; we thought this was a handsome installation and tried to do something similar. Various pieces from individual temples are grouped together and they are masterpieces. But let's be honest, there is really no contextual sense at all, either in Paris or in New York. Each work is isolated and largely silenced on its pristine pedestal in the company of other deities from different temple complexes, and their formal, aesthetic character trumps their religious and cultural meaning. That is, of course, how the art museum – of yesteryear, at least – valued them; and, I must say, to the horror I'm sure of some younger academically minded readers, that is also what I first seek in them: mastery of form, expressiveness, and so forth.

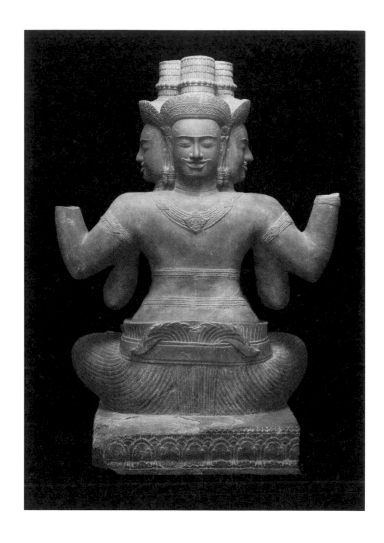

Brahma from Prasat O Dambang,
Cambodia, *c.* 925–950

As to dislocation from context, I should note, perhaps, that this has been going on for millennia. The Romans turned the Greek cult statues they plundered into objects for civic adornment or enrichment; we display statues from Gothic churches for their aesthetic qualities.

These objects would have had a quite different and more profound effect on 13th-century Cambodians from the impact they made on Philippe and me. The nagas, to them, were ancestors, a race of serpent people who lived on the shores of the Pacific. The daughter of a naga king married an Indian prince, and from their offspring descended the Cambodians. A naga with an odd number of heads stood for male energy.

After a while, we walked into the gallery next to the Khmer hall and Philippe stopped in front of a beautiful, headless figure that is, according to the label, a torso of a Buddha from Mathura, Uttar Pradesh, India, from the Gupta period – around the first half or middle of the 5th century AD – carved in pink sandstone.

PdM I tend to prefer serene and quiet works, and to like arrested movement or, as in the case of this figure, total stillness and immobility.

In fact, the Asian works that Philippe is especially attracted to have some of the qualities he loves in Poussin or Saenredam: tranquillity, restraint.

PdM What also appeals to me immensely is how this Gupta-period sculpture demonstrates the way formal qualities in the art of one culture can seem to echo those of another elsewhere on the globe. For example, Romanesque sculptures from the Auvergne also have these repeated patterns in the folds. There is something about the recurrence of such patterns that seems universal, because to a large extent the model for all humans, whether they had contact with each other or not, is man himself and nature. In some places, the repeated lines are in the sand dunes, elsewhere in the waves of the sea. We are surrounded by them wherever we are, as we are with basic geometric

Torso of a Buddha from Mathura,
Uttar Pradesh, India, Gupta Period, 5th century

forms. It should also be said that repeated folds in so many cultures may also be regarded as a stylization.

MG It reminds me a bit of the Romanesque Christ above the portal at Vézelay in Burgundy.

PdM And so very stylized it is! But back to the fragmentary sculptures around us, the truth is that it never bothered me, nor even occurred to me when I first saw these works in the 1960s, to think twice about the fact that the right arm was broken, or that the head and half the mandala were also broken off. 'O tempora o mores', to quote Cicero. It was then in the nature of things; I accepted it, took it for granted.

I concede I am grateful to be able to enjoy the torso in isolation as a pure work of aesthetic merit in Paris, without having to brush away mosquitoes, but I'm more conscious now of the role it might once have played in a Buddhist temple. The world changes, we change and our consciousness is always modulated by the thinking of the moment.

———

From the Musée Guimet, a 19th-century building, with a cool, modernist interior, we crossed the Seine to a newer, and very different, institution. The Musée du quai Branly is the newest of the major museums in Paris. It opened less than a decade ago, in 2006, and was a pet project of Jacques Chirac, successor to François Mitterand as President of France.

The collections are not new. They were previously housed in the old Musée national des Arts d'Afrique et d'Océanie and the Musée de l'Homme. It is a large and expensive new institution devoted to … well, as Philippe quickly pointed out, to something that for various reasons has become rather difficult to name. Indeed, he is inclined to view this whole institution as a case of mis-classification: a museological filing error.

PdM This is one of the first museums anywhere devoted entirely and only to what was once called 'primitive art', at other times *les arts*

premiers, the first arts, which is no better or worse a name than any-
thing else, including indigenous art or 'tribal arts', which I think
auction houses still use. The word 'primitive' has been applied to the
art of peoples without writing – without texts – in various regions
of the world where memory is based on strong oral tradition. Or,
at least, that is what is usually conveyed. But if that is the case, then
what are two millennia-old stone Maya and Olmec pieces doing
next to Oceanic bark paintings of the 19th or 20th centuries? These
Mesoamerican civilizations had stone architecture and, most impor-
tantly, writing. The truth is, the conflation of sub-Saharan African,
Oceanic, pre-Columbian, Native North American art, and others, as
a category is because objects once assigned to ethnographic collec-
tions entered art museums at the same moment. Art museums were
already structurally fully formed and expediency as much as anything
else accounts for these cultures being shown together. It doesn't solve
the anomaly to create departments of 'the Arts of Africa, Oceania,
and the Americas'; it is merely a way, a meaningless and confusing
one at that, to do away with the term 'primitive'.

MG Our guidebook tried 'non-Western art'. Then you have to say
non-Western art, excluding the Far East, India, South East Asia, and
one or two other places.

PdM All the names are flawed: departments called 'The Arts of Africa,
Oceania and the Americas', for example, do not include Federal fur-
niture, Pharaonic statuary, or Almoravid Korans. But is that the real
problem, or is it, more fundamentally, that there was no 'art of the
Americas', no matter how you cut it? There were multiple civiliza-
tions in the Americas, which is a very different thing.

MG It gets clumsy.

PdM What all this points to, actually, is that the issue is not so much
the name we use as the 'it' that the term 'primitive' is meant to

encompass. The bunching together of Oceanic, sub-Saharan African, Mesoamerican and Native North American is where the problem lies. The bundling together of this disparate material from unrelated cultures as ethnographic is a distinctly imperialist–colonialist concept. Then, with a nudge from modernist artists and their fascination with these non-Western, pre-industrialized cultures, we in the West decided, quite logically, that these cultures had a place in art museums.

Yet recognition of their aesthetic worth does not resolve the 'strange bedfellows' issue, the juxtaposition of so many objects that were made for different reasons by people who had no knowledge of each other's existence. Let me return to the Olmecs and Maya, with their monuments and statuary, many of stone, their cities and their age, back to 2000 BC, and their literacy (mostly destroyed by the conquering Europeans); they are, for me, closer in character to the Egyptians, with whom they had no more contact, of course, than to the woodcarvers of the Ivory Coast. So call these displays what you want. The name is not the real issue, and if we struggle with the name, it is because you can't give a name to a fiction. Amazing to me is that in the 21st century, this fiction should have been perpetuated, and so publically, in a major capital, through a high-profile museum, by a prestigious architect, all with official, presidential backing. But then, I'm bound to say that it was during my directorship that the Met changed the name but not the 'bundling' of these same diverse cultures, which continue to occupy contiguous spaces. There were many practical, legal and other reasons, and they remain a reality. However, some day this must be addressed properly – not just at the Met, but everywhere.

While the Musée du quai Branly (or MQB) may be rather coy, verbally, as to what it is actually a collection of, it is certainly forceful architecturally – though in a very different manner to the Musée Guimet, which proclaims 'museum' in a 19th-century European manner, with its classical columns on its curving portico. The MQB presents a face to the world that is partly

composed of lush vegetation. One of its most beguiling features is the 'green wall' facing the main road along the south bank of the Seine, the surface of which is entirely composed of living plants.

To get to the museum itself, you have first to walk though a garden, which is in itself a delightful addition to the amenities of Paris. But Philippe is not entirely convinced by this stratagem on the part of the star architect who designed the museum, Jean Nouvel.

PdM The building itself is an interesting and attractive structure …

he conceded, but …

PdM Even before you go inside, Jean Nouvel transports you from urban Paris into rainforest. Is this a legitimate and natural transition to another world and different continents, or is it yet again a neo-colonialist stereotype? Plants are painted on the glass, an evocation of the equatorial vegetation. We are meant to feel we are in the tropics, not in Paris. As if every object in the museum came from such a tropical setting.

We bought our tickets, entered, and began what turned out to be a quite lengthy journey towards the actual displays. This was a walk up a spiral ramp and – symbolically – a voyage up a river, as if the visitor were travelling along the Congo or Amazon, into the heart of a tropical continent. In the central cylinder around which we progressed all manner of items could dimly be seen, piled up in the dark: drums, spears, masks, carvings, textiles.

PdM Now, count the number of steps you take before you ever get to the museum itself.

We walked on for a while, then the ramp took a final turn and we emerged onto the main floor, a place of twilight interspersed with sumptuously saturated pools of light illuminating the objects on display.

PdM Here at the top of the spiral all of a sudden, out of nowhere, is a Dogon figure from central Mali!

MG It looks fabulous.

PdM Oh, the works are sensational. If you want to see them in a purely aesthetic way, this succeeds. But there is a bit of Disney-fication, isn't there? You're in the dark, with no daylight at all. Yet many of the regions represented are flooded with sunlight, although of course in some areas, under the cover of trees, it is dark. But the surfaces in the museum are all shiny, with reflective red-stone floors. This shininess combined with murkiness is the direct opposite of the actual experience of being in the tropics – or so I infer, having never been any closer to those regions than the Caribbean.

MG It's a labyrinth. So it suggests confusion. We're lost in the forest of a postmodernist architect's imagination.

PdM I hate this place.

Hunting Lions
at the British Museum

The painter Frank Auerbach once said you would have to have an inordinate greed for masterpieces to want to go anywhere other than London. We found it hard to choose where to visit in that city. Indeed, we went to more places than there is space to describe here: to the V&A, where Philippe paused over the medieval ivories, to the Royal Academy, to Sir John Soane's Museum. If we did not fit in the National Gallery it was only because time was pressing.

Philippe's first destination, however, was the British Museum, which contains some of the works closest to his heart: not French or Spanish, but from the ancient Middle East. By mid-morning, we were standing in the Great Court, the central space in the BM that functions as a sort of anteroom to the culture and history of the world. In one direction is the culture of Africa, in another Ancient Egypt, over there the ancient Americas; this way Sumer, India, the Pacific; up a floor you find objects from Prehistoric Europe and works from China and Japan stretching away in case after case. Faced by this choice, however, Philippe was in no doubt about what he wanted to begin by seeing.

PdM I don't think I've ever been to the British Museum without first going to see the Assyrian lion hunts.

MG Why?

PdM As my best and most honest answer, I'll provide a quote from the *Pensées* of Pascal: 'Le Cœur a ses raisons que la raison ne connaît point' ('The heart has its reasons that reason cannot explain.') So, Martin, it is hard to say. What I won't say, though, is that it is because they are among the greatest achievements of a great civilization. That is too impersonal and if that, then why not the Parthenon Marbles? So why the lion hunts? Perhaps this will come through as we look at them and some of the other Assyrian reliefs nearby.

So we stepped out of the Great Court and stopped in front of an enormous snarling lioness, over 8 feet tall and carved out of a massive block of stone. It once stood sentinel in front of a temple dedicated to the goddess Ishtar in the city of Nimrud, known to the Assyrians as Kalhu.

PdM When this colossal and menacing guardian lion was made, I'm sure the inhabitants of Nimrud were convinced that a powerful spirit inhabited the stone. It must have struck utter terror into anyone coming near the temple.

It was created almost three thousand years ago in the reign of the Assyrian ruler Ashurnasirpal II (883–859 BC), but it is still menacing. It looks like an emblem of ruthless power.

PdM It is not just a representation of power, it is its manifestation, its embodiment; its spirit and its power are embedded in the stone as a living force.

The beast's body is covered by cuneiform script: a prayer to the goddess Ishtar, followed by a list of the great deeds Ashurnasirpal II had performed.

Colossal statue of a lion from Nimrud (ancient Kalhu),
northern Iraq, Neo-Assyrian, *c.* 883–859 BC

Colossal statue of a winged human-headed bull from
the North-west Palace of Ashurnasirpal II, Neo-Assyrian, 865–860 BC

PdM The inscription is an integral part of the piece. Even the many illiterate ancient Assyrians, seeing the writing, would have understood that the lioness was the bearer of an important message. Through the sculpture, the ruler/God is speaking.

'Hark…' it roars.

We walked on between two even larger guardian beasts. These, known as lamassus, are human headed, bearded and winged, and look a little like something from C. S. Lewis's Narnia or the Harry Potter novels, which is perhaps not surprising since these strange creatures powerfully affected the British national imagination from the moment they arrived in London in the 1850s. Because their weight – some 30 tons each – makes them hard to move, they have been in this position for over a hundred and fifty years.

PdM They were buried for two millennia, and when they were uncovered, the local population became agitated and frightened, convinced they were malevolent spirits, djinns perhaps.

Archaeology in the Near East at that time was prompted not so much by an interest in antiquity as by a desire to recover and confirm the main events of the Bible. When, in the 1840s, the Englishman Austen Henry Layard chanced upon Nimrud, and the Frenchman Paul-Emile Botta, Khorsabad, the great joy was discovering that these biblical sites had indeed existed.

When the sculptures arrived at the Louvre and at the British Museum, they were greeted strictly as historical documents. British Museum curators, as I mentioned en passant earlier, saw them as crude curiosities, not as art. Classical antiquity was very much the canon, the gauge by which to measure all art. Furthermore, when the Assyrian pieces arrived, it was only some twenty years since the Elgin/Parthenon Marbles had turned the art world on its head; up to that time, Greek art had been judged mostly by looking at Roman copies.

The British Museum floor plan is still expressive of the surprise caused by the arrival of these carvings from what was then known as Mesopotamia.

No one had suspected the existence of Assyrian art when the building of the BM was inaugurated to Sir Robert Smirke's neoclassical design. It was intended to house a collection showing the ascent of art from Ancient Egypt to a pinnacle in Greece, followed by Rome.

When the Assyrian works excavated by Layard arrived, a space for them had to be sandwiched in. That is where most of them still are: squeezed into narrow galleries between the grand Egyptian rooms and those devoted to Greek art.

The lamassus flank an arch leading to the Balawat Gates. These, one of three pairs found in a smaller city north-east of Nimrud, were made in the reign of Ashurnasirpal II's son Shalmaneser III. They were, it was recorded, made of sweet-smelling cedar wood, and turned on cylinders of cedar set in stone sockets. On them were set eight bands of bronze, each embossed and inlaid with numerous scenes. The king is shown on an expedition to the north on which the source of the river Tigris was discovered in what is now eastern Turkey. Other pieces of bronze depict Shalmaneser receiving tribute from the subject cities of Tyre and Sidon, and attacking a town in Syria.

PdM These gates put a whole saga in front of our eyes. As we look closely, engaging fully with them, we are transported back in time some 2,500 years – and these aren't just words; we really have left Bloomsbury and the 21st century, and even stepped out of ourselves. We are floating in a time warp outside of time, totally immersed in the contemplation of a great civilization come to life. This is the effect great art can have. This is why many of us re-engage with it so often once we have tasted of the experience.

Here is an incredibly rich narrative, with so many different scenes of warfare, the hunt, tribute, warriors, chariots, that simply to walk by, stop and merely glance at the scenes, would be to do little more than take inventory of what's there. So for once, I am grateful for the placement in constricted spaces. We have no choice but to stand close to the reliefs and one would have to be totally benumbed to remain indifferent to their vivid and endlessly enthralling narrative.

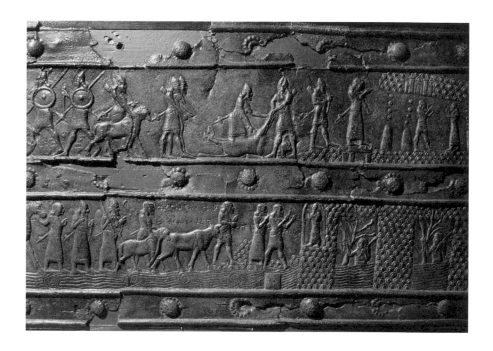

Bronze band from the gates of Shalmaneser III,
Assyrian, *c.* 853 BC. Balawat, Assyria, Ancient Iraq,
The upper scene shows the king discovering the source of the river Tigris;
the lower scene shows a sacrificial bull and ram.

The trouble is that there's more than a lifetime of looking just in the BM, the Louvre or the Met. Although Philippe and I took a long look at the Balawat Gates, we did not truly give them the time they deserve because we had another goal. Dearer to Philippe's heart are the stone reliefs from the ancient city of Nineveh that are on display in the rooms next door. We began with the ones Philippe loves most of all, showing King Ashurbanipal (668–627 BC) hunting lions.

PdM These lion hunts, and especially the wounded, dying lions and lioness occupying a whole relief in their own, singular agony, like a martyrdom of St Sebastian taking up the whole field of a European painting, are, for me, at the pinnacle of art. To say this, some twenty yards away from the sublime sculptures from the Parthenon may seem sacrilegious, but I say this without qualification.

Before we turn to the lions themselves, let's stop at this relief, which is central to the theme of the sequence: it is the king himself, standing erect, confident, godlike and victorious as his left arm holds off the charging lion and his right thrusts his sword forward, piercing the lion's chest through and through. The king is impassive, invincible; the lion enraged and in his last, desperate but futile leap at his executioner. This is an uneven combat, as it has to be, as the reliefs are meant to glorify the king.

Let's look at three of these regal beasts, so noble and pathetic. First at the lion striding forward, pierced by four arrows, head starting to sag, blood flowing out of its mouth, left front paw going limp – what a sense of observation! Then this other lion, pierced by one arrow, slumped on its hind legs, straining to keep head high while torrents of his lifeblood pour out of his mouth; he looks as bemused as he is exhausted and miserable.

Just look now at what may be the most supreme of these reliefs, that of the dying lioness. And I am hardly the first to express unbridled enthusiasm for it as it is surely one of the most unforgettable images in all of art. You can almost hear the startled, weakened roar of pain, and observe the lower part of her body, her sagging back

already paralysed by the arrow in the spine, leaving her hind legs dragging behind, limp, useless.

These beasts are observed with a piercingly accurate as well as sympathetic eye and their suffering is rendered with incredible specificity as to the condition of each. Yet these beasts are not naturalistically rendered at all. The essentials, especially the musculature, are encoded in a highly expressive linear, abstracted vocabulary of form; a highly sophisticated shorthand for the most striking characteristics of man or beast. All the more emotionally wrenching for that, perhaps?

One learns that these reliefs were once brightly coloured (as were the Parthenon Marbles). I don't fret about this. I do not live in the first millennium BC, but today, in my own time. I see these reliefs as they have come down to us irretrievably altered in the unforgiving operating room of time; in this case, buried for millennia under tons of rubble. We are now conditioned to like them stone-coloured, and I do. So I don't long for colour any more than I long for the fortepiano in listening to early Beethoven; I like the sound of the modern piano, the instrument of my time.

MG The paradox of these reliefs is that what they depict is often killing and cruelty. They were placed on the walls of palaces, some in the inner sanctum, the living quarters of the ruler himself, so that he could luxuriate in his own glory. The deaths of the big cats expressed to the Assyrian spectator, perhaps, the imposition of divine order on the world. But it is hard to look at them and not to feel sympathy for the victims – the animals, the enemy warriors being killed, tortured and imprisoned (a group of them forced to transport one of those huge human-headed bulls).

PdM And yet, officially, I don't think that is what the programme called for. The lion hunts were first and foremost displays of the power of the king, glorifying his reign. But I can't help agreeing with you, not being in the skin of one of Ashurbanipal's subjects

Two reliefs from the North Palace of Ashurbanipal, Nineveh
TOP The king kills a lion with his sword, Neo-Assyrian, 645–635 BC
ABOVE Dying Lioness, Assyrian Period, 660 BC

compelled to blind obedience. At the same time, these works are the creation of individual artists, and while they looked upon the lions as many hunters do today, as game, I cannot believe that on some level they, the artists, did not empathize with the lions.

As in Egyptian art, people are always shown with their heads from the side even if the remainder of their body is seen from the back or the front. The depiction of the king, especially, is very far from realistic. He is a ritual being, a sacred king, represented in a standardized way. The proper response of the Assyrian viewer was explained in the cuneiform texts, using words such as 'radiance', 'wonder' and 'joy' – the correct emotions for experience of the sacred. Within the conventions of Assyrian art, however, there was room for an enormous amount of observation, particularly of animals and the natural world – of precisely the way a dead lion's paws flop, how its head sags.

PdM The king has to be represented in a hieratic, predetermined and specific way, but animals such as lions could be treated with much greater freedom.

A pause during which Philippe silently examined and enjoyed these ancient strip cartoons, carved in gypsum or alabaster, and showing the deeds of rulers who lived some two hundred years before Socrates was born.

We emerged at the end of the gallery and came to a crossroads in the museum – and in art history. Ahead was one of the long, grand galleries that display the BM's largest Egyptian sculptures, towering over them a huge granite carving of the Pharaoh Ramesses II (which inspired Shelley's 'Ozymandias'). To the left lay the rooms containing some of the greatest works of ancient Greece, including, most famously, or notoriously, of all, sculptures from the Parthenon in Athens.

MG Shall we turn into the Egyptian galleries, visit the Greek ones or go back into the Assyrian rooms?

PdM It is startling to walk down a corridor of Assyrian art, and suddenly step into the classical world. I still haven't recovered from seeing the Assyrian reliefs. It's very difficult to decide. My eye is drawn to these colossal statues of pharaohs, to that recumbent Greek lion, to those great stelae – but my knees hurt and my back aches, and one's visual and perceptive energy fluctuates as the body wearies.

To see the Parthenon Marbles we ought to have started the day there, looked at them in quantity and for a long time, and gone back the next morning and seen them differently. It was then ten to one and we were thinking about whether we should have lunch.

CHAPTER 22

Lunch in
the Great Court

On the way to the café in the Great Court of the British Museum Philippe
paused in front of a colossal Greek marble lion of the 3rd century BC.

PdM This isn't the only large sculpture that inhabits this vast space,
there are also an Egyptian obelisk, a Chinese guardian figure, and
there, by the shop, and from some vantage points seen *through* the
shop, a life-size Roman equestrian statue. I understand why they were
placed there: better to define the space, to provide scale, and to act as
reminders of the art beyond, in the galleries. We've all done this, and
at the Met we installed very large statuary in the Great Hall as well.
But we must all understand that, here at the British Museum, in this
vast open space, this is in a way throwing away the object, the monu-
ment; turning it into a marker, a trophy almost. Just another of the
imperfections of the museum, generically.

I suppose this is yet another example of why Philippe thought to call this
book *The Art Museum: An Imperfect Construct.*

We reached the café in the Great Court, and found a space at a table, bought some drinks and sandwiches. As we chewed these, and also chewed over what we had been looking at that morning, I offered a thought:

MG Isn't the whole process of art history and appreciation a matter of creative misunderstanding? We look at images from long ago, and find in them what makes sense to us. The pathos that we find in the dying lions might not be what its maker or first audience saw at all.

PdM That's probably true. What's more, they weren't conceived as works of art. So there is an issue of intention.

MG So what are we responding to when we look at these ancient stones?

PdM Undeniably, the lion hunts were made by extremely gifted artisans from the point of view of the sheer craft of carving the stone. And there probably was a master artisan who conceived of the series, someone quite intelligent with a keen sense of design and a highly sophisticated artistic sensibility, higher surely than our own. Isn't that what we all seek in museums? To be raised up, to have our world enhanced by the contemplation of surpassing works of art? To those who would seek a low common denominator in what their museums do in order to 'relate' to their public, I would simply say that confronting greatness does not diminish us, on the contrary. Goethe pointed this out when he marvelled at the Rondanini Hellenistic head of Medusa now in Munich's Glyptothek and said 'The mere knowledge that such a work could be created makes me twice the person I was'.

MG An archaeologist would say that the killing of lions was an expression of the regal power of the Assyrian ruler, consequently the vivid expression of the lion's suffering and death might have just given the original audience pleasure, as the sight of Christians being eaten might have to the spectators in the Colosseum. The fact is, we

don't know. It's often the same with Greek art, with the Parthenon Marbles, for example.

PdM Yes, of course, we no longer live in the age of Pericles but two and a half millennia later. Times are different, we are different, and the object is different in its physical appearance and its meaning. We can go back to the example of the Assyrian reliefs; today they no longer have their polychromy and some are broken; and now they do not glorify any ruler but exist simply as historical and artistic monuments. Neither of the earlier contexts can ever be retrieved any more than we can get into the head of a first millennium BC Assyrian. It is often written that we must look at objects from a distant time or another culture on its own terms; this presumes that one understands those terms, which, very often, is not the case. Yet we can still appreciate the work; we simply need to be aware that we are applying our own standards, our own concept of art and that these are most likely alien to the original intent or function of the object.

MG The word 'context' seems to be the crux of a great deal that we've said about museums. And since we are talking of antiquities, could you say a bit more about the archaeological context, what you called earlier the find-spot?

PdM As I've said before, the find-spot is the last context of an object and it is crucial to preserve it, but it hardly tells the whole story.

After all, we can impute a great deal about an object even without its find-spot context, based on its affinity with a critical mass of similar objects already out of the ground and now mostly in museums. A Greek vase, for example, will no longer reveal information about the specific tomb from which it came, but still a fairly secure date and attribution will be possible, as well as an accurate reading of the subject depicted.

The issue, even without getting embroiled in its legal side, is hugely complex. For example, were you offered on the market a

certain ivory yakshi (an Indian divinity of feminine beauty), you would date it, based on comparisons, to the 1st century AD, and you would assume it had been found in Afghanistan or West India. You would be correct 99 per cent of the time. But I am now referring to a specific piece, one that was discovered not in the East, but in Pompeii. Had it been spirited away in the dead of the night, an important testimony to the active trade between the western Mediterranean and the East would have been lost. So of course we must deplore the looting of sites. But I was alluding to the complicated issues of 'original context'. Let me give you one more, quite different, example. I begin with a question.

What is the context for the French 19th-century finds at the archaeological site of Susa, Iran? The Susa find-spot? That is indeed their archaeological context. But these monuments, now in the Louvre, are the Stele of Naram-Sin, celebrating a major Akkadian victory, and the Law Code of Hammurabi, the first code of law ever promulgated. The contextual issue becomes interesting when you realize these works were made in Babylon, present-day Iraq, not in Susa, Iran. They had been taken as war booty by invading armies from Iran as far back as the 12th century BC.

So, what is their original context? Babylon where they were made and whose civilization they represent, or Susa, their conqueror and resting place for some 3,000 years? The answer, of course, is both, as, like so many other objects, they had multiple lives, and here is a case where the museum is arguably their most logical modern context. There, both ancient contexts can be recreated through display and labelling, and changed depending on which moment in the objects' history the curators wish to emphasize.

MG The conclusion, then, seems to be that sometimes there is no context that is completely, obviously correct. If the Victory Stele of Naram-Sin and Law Code of Hammurabi were sent back to southern Iraq, or to a museum in Iran, it would have a different context and so a slightly altered meaning.

Victory Stele of Naram-Sin, King of Akkad,
Akkadian Period, *c.* 2250 BC

Law Code of Hammurabi, King of Babylon,
c. 1792–1750 BC

But they would still be in a setting – surrounded by the living cultures that evolved from the ancient Elamites, Medes and Persians – that would give them a meaning. As we said in Florence, seeing something in the place for which it was made is a rich experience.

PdM I don't think this is the case in this instance. These pieces, aside from having no connection whatsoever to today's local Muslim communities, were in fact unknown until French archaeologists dug them up from deep in the ground. In Florence, while we may not be of the Quattrocento, we do live in a continuum of its artistic, cultural and religious traditions. Not so with the monuments from Susa: they are vestiges of long-lost civilizations. On the other hand, while 'Elamites, Medes…' are names out of history books and not anything you can experience, a case could well be made for the light, the landscape, the flora…

MG Recently, I went to Olympia in the Peloponnese for the first time. I had a wonderful visit there, looking at the ruins then strolling a couple of hundred yards to the excellent little museum that shows the sculptures from the site. Olympia was rediscovered by an Englishman in the 18th century, the excavations were begun by the French in 1829, but most of the work was done by teams of German archaeologists in the late 19th and 20th centuries (including during the Second World War). I was delighted, however, that none of these had removed the sculptures of the Temple of Zeus or the Hermes by Praxiteles.

If those had been transported to London, Paris or Berlin – as they easily might have been – they would have lost their connection with a particular place: the Hill of Kronos. The river Alfeios flowing nearby is actually represented as a reclining male nude on one of the pediments of the Temple of Zeus.

Of course, if the sculptures were on show in the Berlin Museums they would gain another context: you could see them near to the later Greek sculptures from Pergamum, for example. But they would lose a lot, too.

PdM You could say the same for the Aegina marbles held in the Glyptothek in Munich since the early 19th century, or so many other works. My view is that we shouldn't rewrite history, and that after an extended period of time the work's life in another context becomes a legitimate and often meaningful layer of its history. Veronese's *Marriage at Cana* was not sent back to Venice after the Congress of Vienna in 1815; it has been since then a major attraction of the Louvre where many artists, notably Delacroix, saw it and learned from it.

CHAPTER 23

Fragments

We came back to the question of fragments, which is where we began. In the next room to the yellow jasper lips in the Met's Egyptian galleries, Philippe paused in front of a display that, frankly, I would have hurried past. It was full of tiny bits of stone.

PdM Let's stop in front of this unprepossessing vitrine and look inside; it would be so easy just to walk past it, but we would be missing something really quite special, a group of very modest, indeed even seemingly inconsequential stone shards. Small flakes of limestone that are called ostraca (the word has the same root as ostracize – things that you discard).

These broken stones were used by artists in Ancient Egypt literally as sketchbooks, either to make a model for a sculptor or as practice for the writing of image-based hieroglyphs (this sparrow may be one of these), or simply as quick sketches to flex the hand, such as this lion hunt, wonderfully fresh and spontaneous. These ostraca show us that even Egyptian sculptors of time-defying monuments left drawings as free and personal as those of any modern artist. Looking

TOP Sketch of a swallow, New Kingdom,
c. 1479–1458 BC, Thebes, Upper Egypt
ABOVE Sketch of a pharaoh spearing a lion,
New Kingdom, 1186–1070 BC, Thebes, Upper Egypt

at these we feel as if we were standing at the elbow of the Egyptian master as he draws for himself; it's like eavesdropping on antiquity.

Our book is composed of fragments: conversations, thoughts, reactions, words and silences in front of great works of art. Let's leave it now with these humble objects, each of which takes us back to a moment of feeling and thought and energy thousands of years ago.

List of Illustrations

Index

Page numbers in *italic* refer to illustrations.